# THIS PATH WE TRAVEL

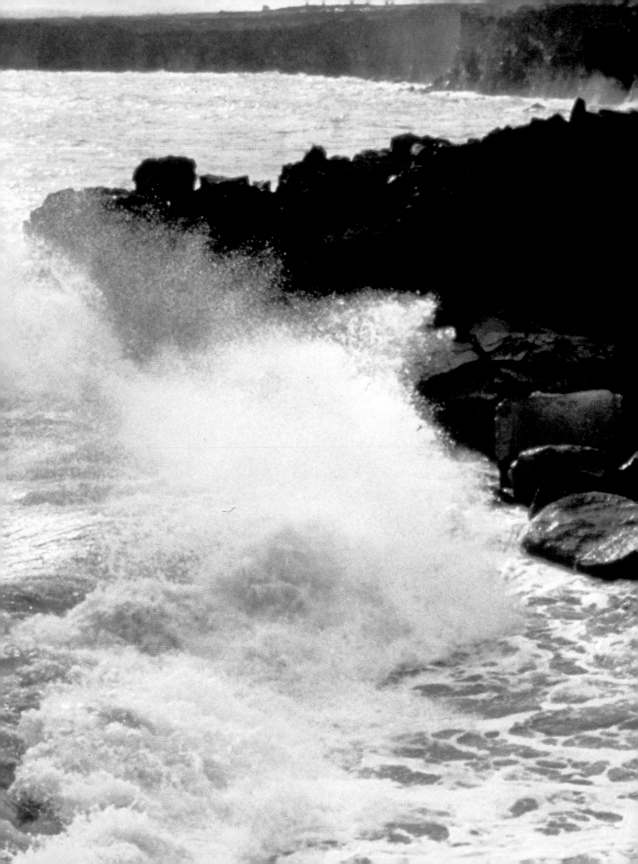

# THIS

# PATH

# WE TRAVEL

### Celebrations of Contemporary Native American Creativity

With photographs by Walter Bigbee

Published by the National Museum of the American Indian,

Smithsonian Institution, and Fulcrum Publishing, Golden, Colorado

Published in conjunction with the exhibition *This Path We Travel: Celebrations of Contemporary Native American Creativity*, on view at the National Museum of the American Indian, George Gustav Heye Center, Alexander Hamilton U.S. Custom House, New York City, 30 October 1994–30 July 1995. The exhibition was sponsored by AT&T. Additional support was provided by Margaret Schink.

Library of Congress Cataloguing-in-Publication Data
This path we travel : celebrations of contemporary Native American creativity/
    [organized by] National Museum of the American Indian, Smithsonian
    Institution; foreword by W. Richard West, Jr.; preface by Richard W. Hill, Sr.
       p.    cm.
       ISBN 1-55591-208-7 (pbk.)
    1. Indian art—North America—Exhibitions. 2. Indian artists—North
    America—Biography. I. National Museum of the American Indian (U.S.)
E98.A7T48 1994
704' .0397'0074753—dc20                  94-17504
                                         CIP

Art created on site, Snaketown, Gila River, Arizona

Terence Winch: Acting Head of Publications
Cheryl Wilson: Editor and project manager
Design by Reiner Design Consultants, Inc., New York
Typeset in Bernhard, News Gothic, and Sabon, and printed on 120 GSM Korean Matte
Printed by Sung In Printing Company, Seoul, Korea

The National Museum of the American Indian, Smithsonian Institution, is dedicated to working in collaboration with the indigenous peoples of the Americas to foster and protect native cultures throughout the Western Hemisphere. The museum's publishing program seeks to augment awareness of Native American beliefs and lifeways, and to educate the public about the history and significance of native cultures.

A note about the photographer: Walter Bigbee (Comanche) is a professional freelance photographer who has worked on several Smithsonian projects. He hopes through his work to "better the understanding of native people to ourselves as well as non-natives."

Front cover: Handprints installation, Alberta, Canada; back cover: Art created on site, Snaketown, Gila River, Arizona
Half-title page: Art created on site, Banff, Alberta, Canada
Title page: Hawaiian surf; spiral design by project artist Dan Namingha
Table of contents: Spider web installation, Hawai'i

Fulcrum Publishing
350 Indiana Street, Suite 350
Golden, Colorado 80401-5093
(800) 992-2908

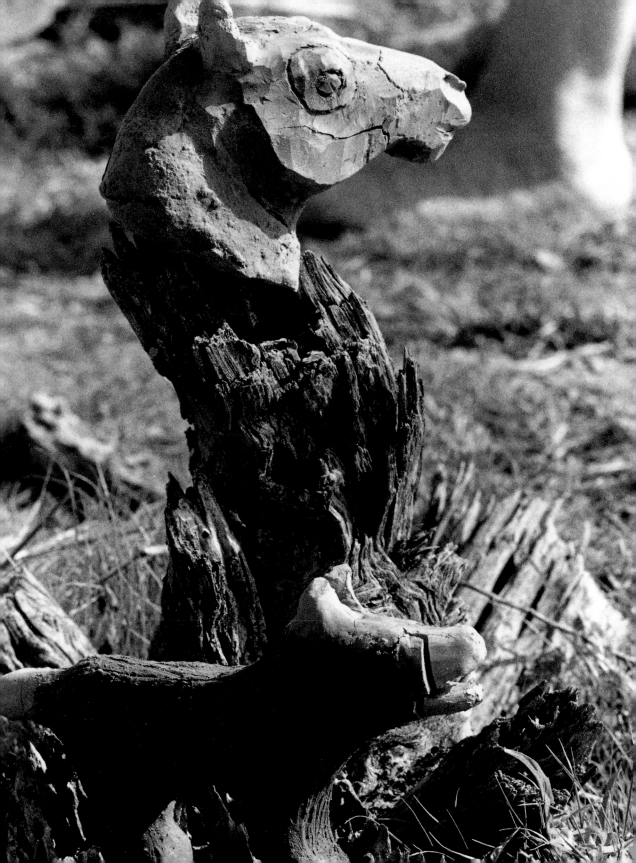

# Contents

IX **Foreword**
W. Richard West, Jr., Director
National Museum of the American Indian

XIII **Preface**
This Path I Travel: Personal Reflections
on the Creative Process
Richard W. Hill, Sr., Special Assistant
to the Director, NMAI

XXVII **Introduction**
Innovation and Tradition
Lance Belanger

1 **Emergence: The Fourth World**
Frank LaPena

23 **Artists' Statements and
Biographies**
24 Arthur Amiotte
30 Douglas Coffin
36 Allen DeLeary
42 Pualani Kanaka'ole Kanahele
50 Margo Kane
56 Frank LaPena
64 Jane Lind
70 Harold Littlebird
78 José Montaño
85 Soni Moreno-Primeau
92 Dan Namingha
98 LeVan Keola Sequeira
105 Hulleah J. Tsinhnahjinnie
112 Denise Wallace
119 Josephine Wapp

125 **Appendix**
125 Curatorial Statement
126 Guiding Principles of the Collaboration

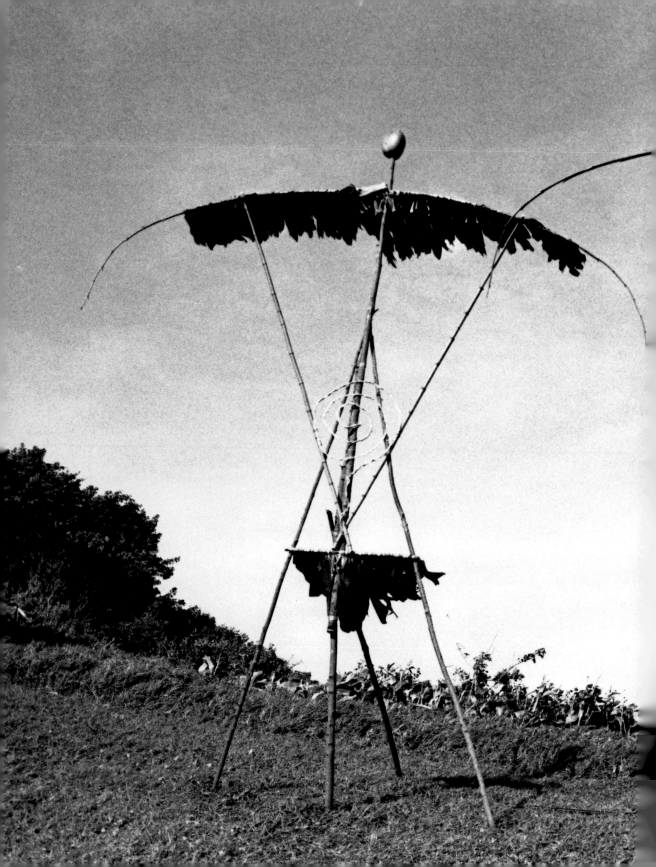

# Foreword

*This Path We Travel: Celebrations of Contemporary Native American Creativity*, along with the exhibition of the same name, says many things about the historical and contemporary state of native art and native life. In this foreword, however, I would like to narrow my focus to several points that, from my own personal perspective, are especially important to this book and exhibition. First, *This Path We Travel* confirms, through the very manner in which it was created by the participating contemporary Native American artists, the distinctive process and place of artistic expression among Native Americans as compared with Western art traditions. For many Native Americans the term "art," as it is understood in a European-American cultural context, did not exist. Unlike most of Western art, the objects created by those we now call native artists and artisans were not valued by their makers primarily as representations of individual creative and artistic expression. The material, instead, was appreciated by the native maker and community principally for its communal, ritualistic, or ceremonial significance. Because the objects made by Native Americans frequently were associated with ritual and ceremony, the process of creating the cultural material was as important, or even more significant, than the object itself.

The artists who collaborated in the creation of *This Path We Travel* emphasize this fundamental distinction between Western art and native art implicitly and explicitly. In their curatorial statement for the exhibition, the artists stated the following:

*We believe this installation is a form of ceremony and ritual. It is based upon an older native model of cooperation and sharing. . . . We bring our own vision and experience to the ritual, which then becomes a multilayered vision of all the participants. Our collaboration therefore is an ancient continuous process.*

In his essay in this book, José Montaño, an Aymara musician born in the highland village of Incalacaya, Bolivia, also provides powerful specificity for the proposition that native art is valued primarily for its responsiveness and contribution to community cultural values rather than for its reflection of individual artistic genius, although the latter may well be present:

*[Ours]. . . is communal music—played for the good of a community, not to bring fame to an individual. The lifestyle of a mestizo musician [mestizo music is characterized by a blending of European and native traits] is individualistic and competitive; the idea is to become famous through entertainment. Mestizo music*

ix

*is sung in Spanish, and the songs are about love. . . .*
*They are fleeting songs, popular today but soon gone*
*and never heard again. By contrast, our native music*
*is part of our total culture; it does not exist just for*
*entertainment or to turn musicians into stars.*

In light of this sense of the fundamental nature of
the art created by Native Americans, their cultural
material has always served as a remarkably
accurate window on the state of native life. Over
time, Native American art has been as brilliantly
adaptive as the people who have made it, and it
has changed in form as native artisans have
responded to the oppositional cultural forces that,
for some five hundred years, have affected,
buffeted, and, in some cases, decimated indigenous
cultures. This cultural and artistic adaptation,
however, should never be confused with assimila-
tion but, instead, should be understood as a
reflection of the strong thread of cultural and
artistic continuity that binds contemporary Native
American artists to their artistic forebears and
antecedents. As the artists of *This Path We Travel*
state, "The work [in the exhibition] will spring from
the traditions of our people *and* will be radically new
in form" [emphasis mine]. José Montaño again
makes this general point very specifically:

*Our history is reenacted through music and*
*dance. The music . . . contains messages from*
*our ancestors about nature—planting, harvest,*
*animals—and about revering our elders and*
*children. It expresses the hopes and prayers of*
*the community. The melodies are handed down*
*from one generation to another and are reinter-*
*preted, but the basic music and message remain*
*the same. As we explored our own musical*
*tradition, we began to have a new conscious-*
*ness about ourselves, our parents, and our*
*grandparents, and to appreciate our own*
*language and culture.*

Margo Kane, a Cree–Saulteaux–Blackfoot from
Canada, is a performing artist and a participant in
*This Path We Travel*. She has captured in spirit,
perhaps, the appropriate end-point for my fore-
word. In her essay she concludes:

*It is a challenge to face our future with resolve and*
*optimism in spite of the negative forces around us.*
*Native people will deal with issues of relocation,*
*identity, status and lack of status, on-reserve and*
*off-reserve, cultural appropriation, contemporary*
*versus traditional art, sovereignty,*
*self-determination, and self-government. Survival is*
*a complex negotiation.*

Cultural and artistic survival for native peoples is,
indeed, a matter of "complex negotiation." In *This
Path We Travel: Celebrations of Contemporary
Native American Creativity*, however, we appreciate
and know again the immense resolve and high success
of contemporary Native American artists as negotiators.

This book and the accompanying exhibition would
not have been possible without the work of many
dedicated people, not all of whom can possibly be
thanked here. The exhibition was sponsored by
AT&T. Additional support was provided by
Margaret Schink. Elaine Heumann Gurian and Lloyd
Kiva New were instrumental in developing the
concept that launched this project. We are especially
indebted to the fifteen artists whose creativity, talent,
and dedication transformed this project from a
concept into a reality. We also want to thank several
initial participants in the project who provided us
with valuable help: Domingo Cisneros, Phyllis Fife,
Lisa Mayo, James McGrath, Howard Rainer, Jacquie
Stevens, Roxanne Swentzell, and William S. Yellow
Robe, Jr.

The text of the book was compiled from essays
contributed by the project artists and from video-

taped interviews conducted with the artists through-out the project. Terence Winch, Acting Head of Publications, provided guidance and editorial direction. Cheryl Wilson edited the text; Lou Stancari and Ann Kawasaki helped with the many details involved in its completion. Frank LaPena diligently coordinated his colleagues' text, and provided advice and assistance on textual matters. Special Assistant Rick Hill and Special Events Coordinator Fred Nahwooksy reviewed the text and offered insights, and Assistant Director Clara Sue Kidwell provided content analysis and review. Alyce Sadongei read the manuscript and offered helpful suggestions. Photographer Walter Bigbee worked with the participants at each project meeting and on-site visit to produce the book's evocative illustrations. Sharon Dean, Pamela Dewey, Karen Furth, Janine Jones, Danyelle Means, and Laura Nash of the NMAI Photo Archives provided the many photographic services required for the book and exhibition. Roger Gorman of Reiner Design Consultants created the unique and fitting design of this publication. Allan Kaneshiro provided illustrations and floor plans of the exhibition design, and arranged with project artist Dan Namingha to create the spiral logo that enhances the design of the book and exhibition. Finally, we are pleased to collaborate on this project with Fulcrum Publishing, in particular Carmel Huestis, Jay Staten, Steve Haberler, and Ed Meidenbauer, who met a very demanding production schedule.

The exhibition was likewise the result of the work of many dedicated individuals. Project Director Jim Volkert guided this complex project through its three years of development; Andrea R. Hanley, Project Manager, directed content development, coordinated project administration, and orchestrated the many details involved in arranging the final installation of the show; Allan Kaneshiro implemented the exhibition design as directed by the project artists; Lance Belanger worked closely with the artists to facilitate site meetings and develop exhibition content; Claudette Fortin and her videography crew documented more than three hundred hours of the artists' activities during project meetings and site visits. The NMAI staff in New York—in particular Kathleen Ash-Milby, Lynne Harlan, Mary Nooney, and Leslie Williamson—arranged tours of the collection and organized the conservation and handling of objects. Karen Fort and Fred Nahwooksy coordinated planning and research during the initial stages of the project; Jennifer Miller handled administrative matters and travel for the project participants. Special thanks go to Academy Studios, who created the faux environment for the exhibition.

We are greatly indebted to the assistance and generosity of the people at all the project sites, including technicians, consultants, and hosts. These include: in New York, Clinton Elliott, Gaetana de Gennaro, Ann Ledy, and the American Indian Community House; in Canada, Dave Drews, Catherine Hardie-Wigram, Tom Hill, Rod Hunter, Larry Provost, Marian Smiley, Steve Smith, Hank Snow, Chief John Snow, Tony Snow, Fred Barney Taylor, Georgina Twoyoungman, Lazarus Wesley, and the people of the Stoney Reserve; in Hawai'i, Maria Brown, Janie Hayden, Na'ala Kealoha, Lynne Martin, Marie McDonald, Linda Moriarty, Cheryl and Clyde Sproat, and the East-West Center, University of Hawai'i, O'ahu; in Arizona, Cecil F. Antone, Joseph Enos, Urban L. Giff, Ben and Joy Hanley, Fred Ringalero, Jr., Enrique Simone, Martin Sullivan, Sheri Tapp, Tom White, and the Gila River Indian Community.

This project could not have been completed without the support and assistance of the Smithsonian's Office of Accounting Services, Office of Contracts and Property Management, Office of Telecommunications, and Office of Travel Services.

W. Richard West, Jr., Director
(Southern Cheyenne and member of the Cheyenne and Arapaho Tribes of Oklahoma)

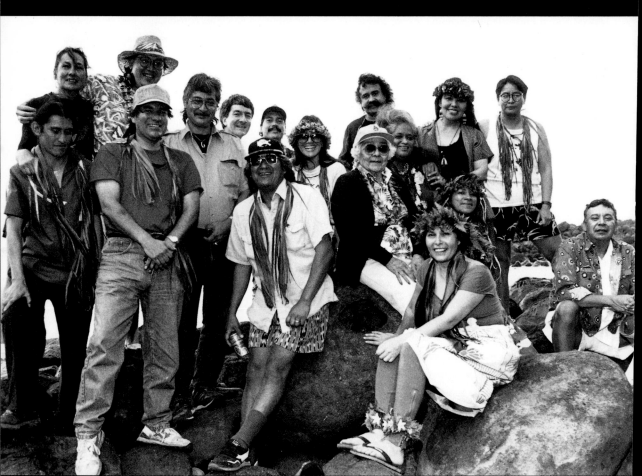

# Preface

This Path I Travel: Personal Reflections on the Creative Process

I became involved in *This Path We Travel* after the project had already been launched, but I was present when it was first conceived. Lloyd Kiva New invited me to his home in Santa Fe in 1990 to meet with some people from the Smithsonian Institution's new National Museum of the American Indian. Several other Indian artists and media specialists were there to hear of plans for the new museum and suggest approaches to using the Alexander Hamilton U.S. Custom House in New York City—which was to become the George Gustav Heye Center in 1994—as an Indian exhibition facility.

Elaine Heumann Gurian and Jim Volkert had been hired to organize the public programs and exhibitions for the new museum, but with a difference: they asked the Indians what they would like to see, rather than having us review a preconceived exhibition plan. That in itself was a monumental step forward for the Smithsonian in the minds of the artists who were at that meeting. Ramona Sakiestewa (Hopi), Arthur Amiotte (Oglala Lakota), George Burdeau (Blackfoot), Doug Coffin (Potawatomi), Dan Namingha (Hopi), Harold and Larry Littlebird (Santo Domingo–Laguna Pueblo), and Dave Warren (Santa Clara Pueblo) expressed the basic hostility and distrust that has separated contemporary Indians from museums for nearly a century. Was it really possible for the Smithsonian to be responsive to Indian art—to see it through Indian eyes, to provide a venue for contemporary Indian art rather than to see Indian art as relics of a bygone era? The lively discussion that night in Santa Fe gave birth to the ideas for an exhibition that would open all the way across the country.

In many respects, the concept for *This Path We Travel* lies in the minds and hearts of the artists present at that meeting. They firmly stated that it was time for contemporary Indian art to be taken seriously at the Smithsonian and within the art circles of New York City. And if it weren't for the willingness of Volkert and Gurian to take risks, try new approaches, and listen carefully to the opinions and insights of the Indian artists, this exhibition would not have been possible. The creative ideas from that meeting supercharged the process.

My next experience with *This Path We Travel* was a chance meeting in New York with the artists selected to participate in the project. I sat in on their discussion

with NMAI director Rick West and listened to all their questions about just what the museum wanted the artists to do. "Create art" was the response. I was amazed. Never in my twenty years of working with Indian artists and organizing exhibitions had this opportunity been presented—a major museum willing to underwrite a creative endeavor where the Indians set the rules. Despite the confusion that existed as to what this exhibition was going to be, I couldn't help but feel a little jealous of the artists.

Two years later, I had a job at the National Museum of the American Indian that placed responsibility for this project on my desk. I eagerly awaited the opportunity to lead the planning into the final stages, mindful of the intent expressed by my friends in Santa Fe and the creative talent that each of the selected artists brought to the project. There were only a few I hadn't met at my previous job as director of the museum at the Institute of American Indian Arts in Santa Fe, and I had a great respect for them and for their commitment to helping other Indian artists gain a foothold in the art world. I felt deeply committed to seeing that this exhibition would truly reflect the Indian intellect as well as the creative diversity of the group. I felt that *This Path We Travel* was going to be the most significant creative expression of contemporary Indian art in a decade.

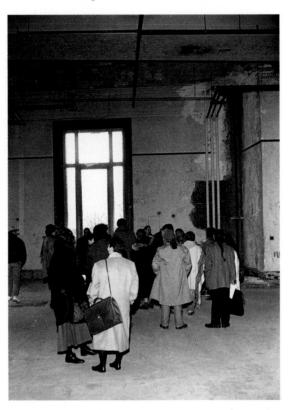

Project artists at the George Gustav Heye Center of the NMAI (at the old U.S. Custom House) before renovations, New York City

In viewing the videos of the artists at work in Banff, Alberta, I was struck by the impact of the collaboration on each artist's work. I was transfixed as I watched them construct a sphere of willows on the rocky banks of a fast-flowing river (see page 124). Two things came to mind—how universal the circle is to Indians and how old-time Indians would have liked to come across that sphere as it sat quietly within the landscape. The simple act of making a sphere from natural materials also seemed to bind the artists together in a common agenda that did not require hours of justification. It was tradition at work, and each hand was important in making it a reality.

The leafy globe rested on two stone cairns in the water. What was interesting to me was that one cairn was slightly taller than the other. At first, you might expect to see supports of the same height, with the sphere evenly balanced in the middle. But the image created by the sphere resting between two uneven cairns held a deeper meaning for me. I thought of the world out of balance Hopi elders had described to me years before. They spoke of a world spinning out of control and the need to set it right again, which could be achieved only by the conduct of the humans of that world. The willow sphere was a metaphor for

that idea, and perfectly represented the ancient ideas of our ancestors, presented by this contemporary generation of Indian artists. The experience of building the sphere became the founding manifestation of the exhibition project. A different sphere, created specifically for the exhibition, will recall for us the power of the original image in Alberta: the surrounding river rocks, the clean water, the majestic mountains, and the artists' hands at work.

Recollections such as this have played a significant role in *This Path We Travel*. Throughout the project, the artists recalled stories of their ancestors, as well as their own life experiences, and used these recollections to initiate creative experiences at each of the four directions. Each artist will carry something old and something new into the galleries of the Heye Center, and by doing this, each has carried tradition a step further.

Another significant aspect of the Banff adventure was the creation of four huge spirit figures—the result of the work of many hands (see page 13). Each effigy took on its own character and would have been powerful-looking standing still. Yet the artists had something else in mind. They decided to "dance" these fifteen-foot figures over a hill. As the musicians in the group played songs, the effigies seemed to skip-step up to the horizon of the hill, then over the brink, and down toward the valley. This was a new ritual to honor ancient ideals, a communal experience created and shared by the artists to reaffirm the ancestral spirits who once walked this earth.

That event made me realize that this process was unique. We could never replicate that experience in the Heye Center, but it was absolutely essential to what this project is about. The creative process is a ritual in itself—the artists all understood that—and for the first time, that ritual as it is applied to contemporary Indian art was recorded on video-

tape. If the whole project had ended at that moment, much would have been accomplished.

Many other artists may be funded to create their own unique experiences and works. But for Indian artists, who often face the stereotyped expectations of others, art has become a commodity of exchange in the cultural tourism industry. What we witnessed in this project is the process of artistic creation without the influence of the marketplace. With no regard to whether they would sell or not, the works were free to be themselves. In addition, the art was created collectively—it belongs to the group, not an individual. I was intrigued by the realization that this may have been the way in which ancient petroglyphs were created—by a group of people seeking to present their collective experiences.

My intrigue was kindled again during the Hawaiian visit, where we looked beyond romanticized notions of white sand, clear blue water, and hula dancers, to the sources of creation that we had all been discussing. Our Native Hawaiian hosts explained their world view, reflected in the characteristics of the indigenous landscape. The lush valley was the male portion of the island; spiders and centipedes crawled on the moist soil at our feet and abundant vegetation and fruit trees thrived there. The volcano at the other end of the island was the female counterpart to this area. Across the dark lava fields lived the active volcano that still creates land daily. As the molten lava flowed into the sea, it produced great clouds of steam that fell back to the lava fields as a refreshing mist. The female creator—Mother Earth—was alive and well.

After hearing the traditional stories of the Native Hawaiians, the artists performed in the life-giving mist of the volcano. While the format might have been different, this is how the old songs, dances, and stories were created, and the artists recalled that

process. Again, I realized that this kind of performance could not be replicated in New York. The mist has to be felt, not imagined. The steaming hiss of the lava hitting the sea has to be witnessed, not just videotaped. The elements of the earth are living, not objects for display.

One afternoon, we went to visit a site where Native Hawaiian petroglyphs were located. It was ironic that a fence had been erected and a sign posted telling us that the site was closed. When we climbed over the fence, I reflected on how strange it was that I felt like I was breaking the law in order to see something that had been left for me centuries before. Walking across an ancient lava bed, we found images of birds, people, fish, boats, and spirits that reminded me of petroglyphs on the mainland. I marveled at the fact that since ancient times, there has not been much Indian art that has the same effect as these images carved in stone. All of the concerns modern curators have about presenting art were not to be found here—only images we admired and walked over. The experience of walking over the land and seeing artworks left as reminders will be recalled in the Heye Center. How would an exhibition evoke all of these experiences in a building so far removed from them, not only in time and space, but in its very design? I was simply convinced of one thing—that the creative energy of the artists would find a way; that is what art is all about.

One rainy evening in Hawai'i, while the women were visiting one of the island's volcanoes, the men sat around and exchanged jokes, stories, and ideas. Harold Littlebird read a poem about his reaction to the volcano. José Montaño played an ancient Aymara melody on his flute. Frank LaPena told of the petroglyphs and mountain spirits in his native California. Then Dan Namingha played a song on his flute, one he had composed about the mourning doves he heard as a child at Hopi. The doves of Hawai'i reminded him of that sound he heard in his youth. His flute recreated that music and evoked a picture in each of our minds of what it was like when we were young, listening to the birds. Among my own people, the Iroquois, we are told that we are to be like the birds who sing their beautiful songs early in the morning as the sun rises, and gather again to sing as the sun sets—like them, we are to give thanks at those very same times.

Dan's song made me wish I could live more like that, instead of rushing to catch an airplane before the birds even start to sing. Anyone who has heard a dove would appreciate the beauty of that Hopi song, played as we looked out across the Pacific Ocean. For that moment, each of us sat quietly and let that one song connect us to each other and to our own memories. It was the sound without words that made us feel a bit more humble, at least for a few moments. It was a gift freely given, from the doves to Dan, from Dan to us. At that moment I knew that this exhibition would succeed, most of all in the hearts and minds of the artists.

To appreciate what is before you in *This Path We Travel*, you will have to try to see beyond the words, hear beyond the sounds, and recall things you may not have known before. Ultimately, by looking at this installation, the artists want us to see ourselves as a part of the creation, a part of what makes life sacred, a part of the solution as well as the problem of the earth-sphere, spinning out of balance.

Richard W. Hill, Sr., Special Assistant to the Director *(Tuscarora)*

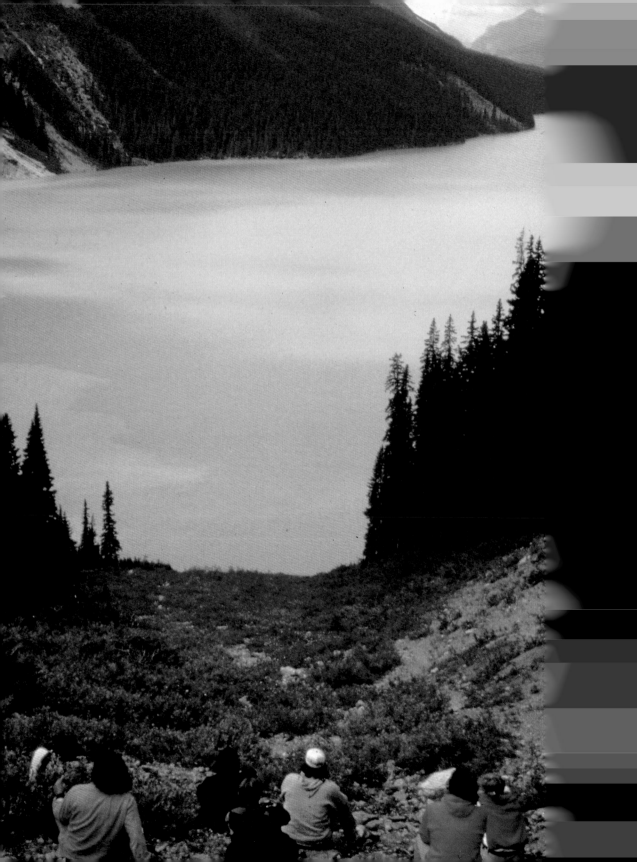

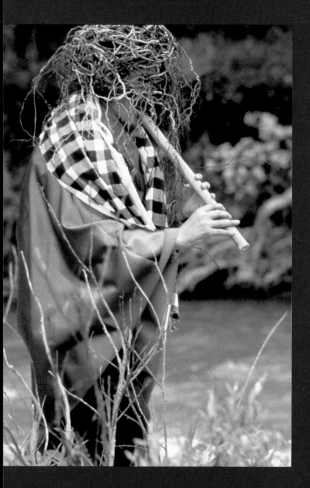

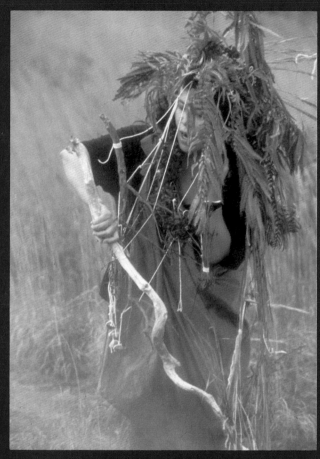

José Montaño,
performance,
Banff, Alberta, Canada

Jane Lind,
performance,
Hawai'i

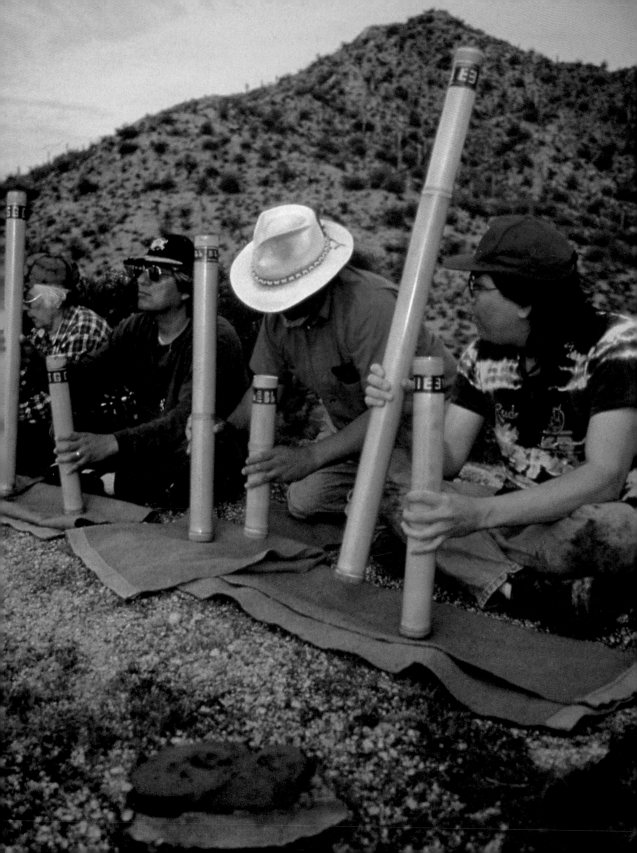

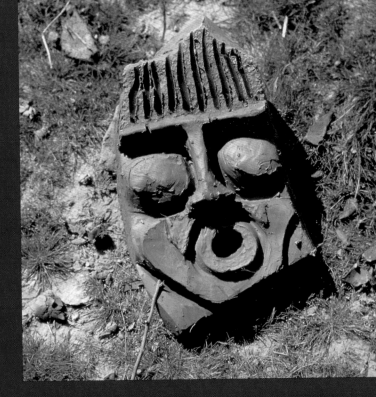

Art created on site,
Snaketown,
Gila River, Arizona

Art created on site,
Snaketown,
Gila River, Arizona

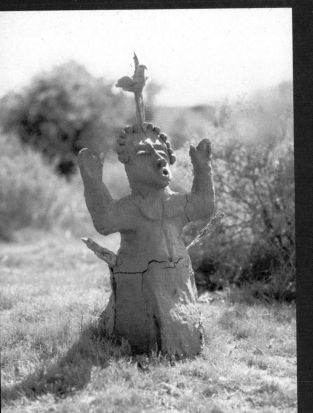

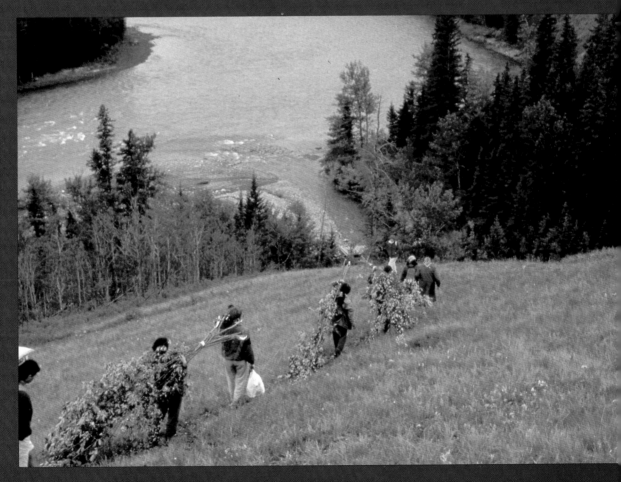

Artists,
Banff, Alberta,
Canada

Josephine Wapp and
Arthur Amiotte
with effigy,
Banff, Alberta, Canada

Jane Lind
with totem installation,
Hawai'i

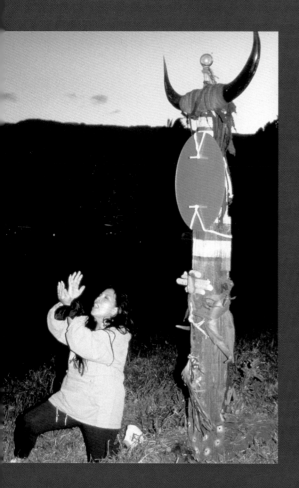

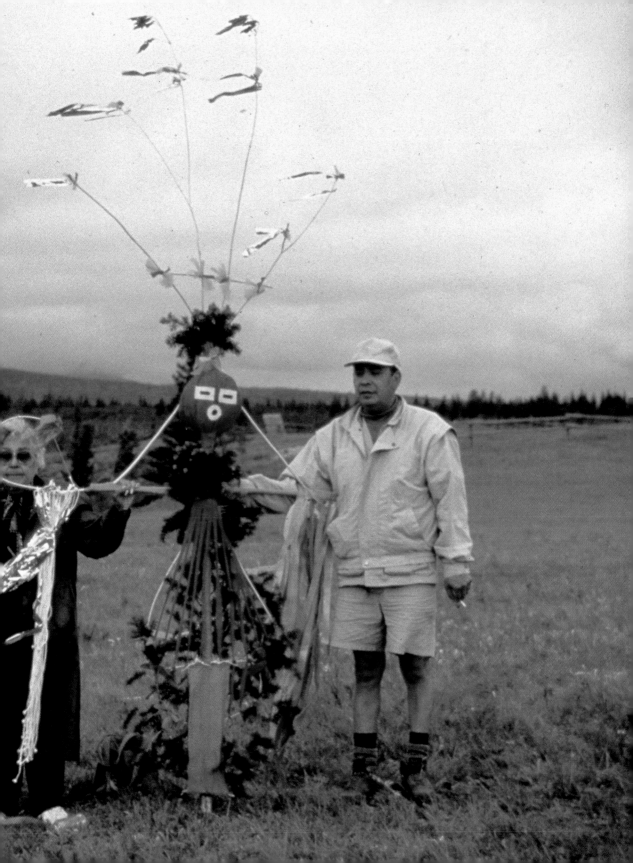

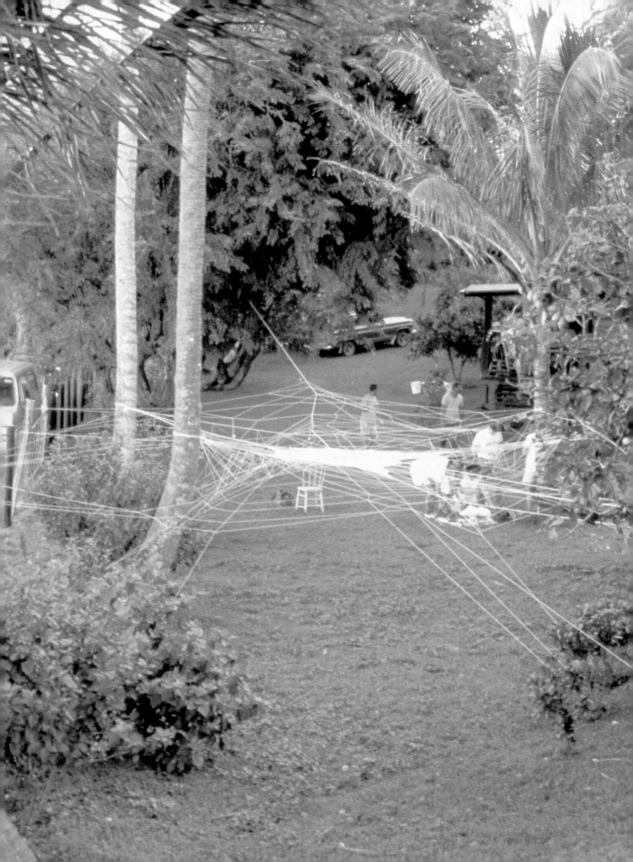

Spider web installation,
Hawai'i

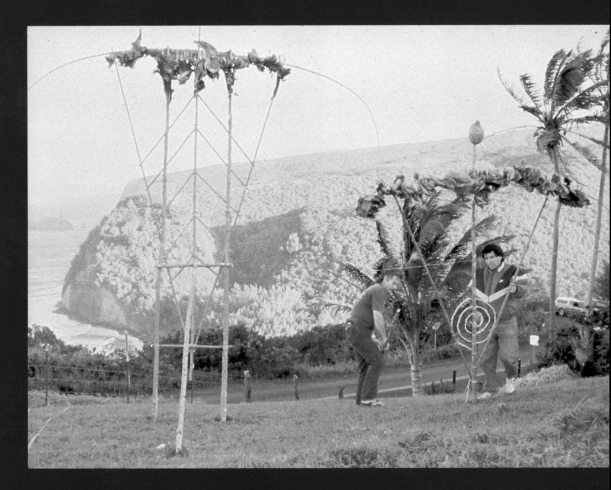

LeVan Keola Sequeira
and Dan Namingha
with effigies, Hawai'i

Totem installation,
Banff,
Alberta, Canada

# Introduction

Innovation and Tradition

## Lance Belanger

*The National Museum of the American Indian shall recognize and affirm to native communities and the non-native public the historical and contemporary culture and cultural achievements of the natives of the Western Hemisphere by advancing—in consultation, collaboration, and cooperation with natives— knowledge and understanding of native cultures, including art, history, and language, and by recognizing the museum's special responsibility, through innovative public programming, research, and collections, to protect, support, and enhance the development, maintenance, and perpetuation of native culture and community.*

—National Museum of the American Indian, Mission Statement

*This Path We Travel: Celebrations of Contemporary Native American Creativity* is an innovative exhibition designed and produced by fifteen contemporary artists representing a range of cultural backgrounds, artistic media, styles, and ages. Despite their diverse backgrounds, the artists were able to create a unified expression of native thought and belief. The exhibition and all its components—the result of a three-year collaborative effort—is something of an intellectual journey into the minds of this hemisphere's indigenous peoples. This book documents the collaborative process undertaken by the artists in visualizing, planning, designing, and creating the exhibition.

The exhibition embodies the charge of the National Museum of the American Indian (NMAI) to educate the public about the historical and contemporary cultures and cultural achievements of the native peoples of the Western Hemisphere. Established by law in 1989 as part of the Smithsonian Institution, the museum is to be a living memorial dedicated to collecting, preserving, studying, and exhibiting American Indian language, literature, history, art, and culture. Slated for opening at the turn of the century, the museum will be located on the Mall in Washington, D.C. The legislation also provides for the establishment of a

second site, the George Gustav Heye Center of the NMAI, located in the old Alexander Hamilton U.S. Custom House in Manhattan. The opening of *This Path We Travel* will help inaugurate the Heye Center.

*This Path We Travel* expresses the continuity of native cultures. Drawing on the past but looking to the future, the exhibition portrays tradition as a series of cumulative steps that build on an understanding of our heritage, yet are modified by the creative influence and vision of the present. While tradition is vital to maintaining cultural continuity, by creating new objects and eliciting different responses, we may foster a better public understanding of our deeply held views. The native belief that tradition is a dynamic rather than a static process is reflected in the design of this exhibition.

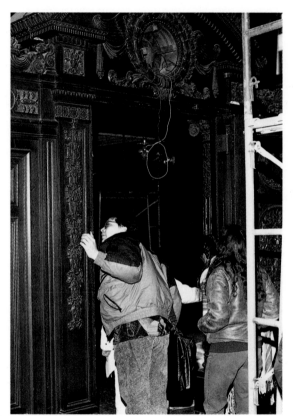

Project artists at the George Gustav Heye Center of the NMAI (at the old U.S. Custom House) before renovations, New York City

The exhibition itself is a form of ceremony based on a time-honored native model of cooperation and sharing as a ritualistic process. Though the work is grounded in the traditions of our people, it is radically new in form; because we bring our individual viewpoints and experience to the ritual, it is a multifaceted vision of all the participants. It is in this sense that our collaboration becomes part of an ancient, continuous process.

Understanding *This Path We Travel* requires knowing something about how the project was born and evolved. Initially, the NMAI, which provided the resources and coordinated activities for the exhibition project, invited twenty-five contemporary Native American visual artists, writers, musicians, playwrights, and performers—all with a commitment to traditional culture as well as a vision of the future—to meet in New York City at the Heye Center to discuss the project; ultimately, the group narrowed to fifteen. The NMAI determined that the artists would meet six times, with the last gathering being the collaborative installation of the exhibition in the Heye Center to celebrate its opening in October 1994.

During the first New York meeting, at which they became acquainted, the artists clarified their task through slides and videos of their art, and readings of their creative work. They also looked at objects in the Heye collection, in order to familiarize themselves with the holdings of the museum. Even at this early stage, certain themes began to emerge that guided the creative process and, eventually, shaped the focus of the exhibition. The artists agreed that celebrating the earth from their perspectives as Native Americans

would be the common aesthetic and cultural thread throughout the process, and that they would convey this theme by using natural materials as artistic media. They also discussed the actual processes they would use to accomplish this mission.

The group determined that the conference format was not conducive to creative thought and output, and therefore scheduled the next meeting at a New York studio workshop. At this second meeting, the artists discussed the significance of the number four in native thought and experience—four seasons, four directions—and how this might be incorporated into the exhibition. They also reiterated their intent to focus on elements of nature and the use of natural materials in the exhibition. Eventually, the artists combined this theme with the concept of using high technology, acknowledging that contemporary artistic expression must by its very nature include modern advances in technology as an accurate reflection of contemporary indigenous experience.

Finally, the artists agreed that the process of the project itself would need a particular structure and design. Choosing spots in different parts of the hemisphere representative of the four cardinal directions seemed the best choice. The group selected New York City as the easternmost location; Alberta, Canada, for the north; Hawai'i for the west; and Phoenix, Arizona, for the south. The artists also concluded that it was important to choose areas where indigenous people live and to involve them in the creative process so that the project would truly be a collaborative one.

The third gathering took place in an environment that challenged the artists' creative output: the starkly beautiful Stoney Reserve in Alberta, Canada, home of the Nakoda tribe. This was the spot for the first experience in site-specific installation and performance. The trek into the Canadian

Rockies was a spiritual experience that inspired the group's creativity. It was a time to merge presence of mind with the spirit of place, a spirit that confirms an indigenous ideology that emphasizes connection with nature.

Some of the artists came to Alberta with definite ideas about what activities to pursue. Harold Littlebird, Santo Domingo–Laguna writer and composer, called on the artists to participate in an on-site performance of a story relating the creation of life. Adorning themselves with the cloth Harold supplied, as well as with natural materials, such as bark, leaves, and pine cones found in the surrounding forest, the group portrayed the animal characters in his tale. Harold inspired the artists to share their own tribes' creation stories—an experience that fostered a sense of collaboration, mutual respect, and enlightenment. Tewa–Hopi visual artist Dan Namingha led the artists in constructing a sphere of willow branches on the shore of the Bow River, around which they danced. Complementing the emotions and spirituality of this event were songs by multidisciplinary artist Margo Kane (Cree–Saulteaux–Blackfoot).

Using wood, stone, hide, and bone found in and around the river site, Potawatomi sculptor Doug Coffin built totemic monuments as testaments to spirit of place.

Denise Wallace (Chugach–Aleut), Arthur Amiotte (Oglala Lakota), and Josephine Wapp (Comanche) fashioned fetishes that, as works in progress, would be transformed as *This Path We Travel* evolved.

Frank LaPena (Wintu–Nomtipom), Harold, José Montaño (Aymara), and I trekked to Grotto Canyon. There, we created a temporary image symbolizing our four different points of origin coming together as a sign of cultural unity. Juxtaposing our hands on the surface of a rock, we

made handprints from the natural pigments found in the mountains (see page 63). A light rain washed away the image, suggesting the temporary state of our existence on the earth.

Inspired by the surrounding environment, José, Allen DeLeary (Ojibway), Harold, and Frank played music to accompany the artists' creative efforts. The natural sounds of the mountains were the ultimate symphony.

The peacefulness and beauty around us were in sharp contrast to the political adversity experienced by the indigenous people of the region. The profound negative effect of Western encroachment upon these people and their land was expressed by Nakoda Chief John Snow, who welcomed us to the Stoney Reserve:

*Indian tradition and oral history say that my people were always present in this part of the Great Turtle Island, roaming along the foothills out onto the prairies to the east and deep into the Rocky Mountain country to the west. . . . In order to understand the vital importance the mountains had—and still have— to my people, it is necessary to know something of our way of life before the coming of the white man. It is not enough to say the mountains were the Stoneys' traditional place of prayer, because our life was not a fragmented one with a compartment for religion. Rather, our life was one in which religion and reverence for nature, which revealed religious truth, were woven throughout all parts of the social structure and observed in conjunction with every activity. Our forefathers were a proud people because they knew they had been selected by the Creator to*

Snaketown,
Gila River,
Arizona

*receive a precious gift of special understanding and they have handed this gift down to us as a sacred trust.*[1]

Our fourth gathering was in Hawai'i. The political climate of the islands—influenced by a native sovereignty movement—made this an ideal location for the next stage of the project. The physical environment of Hawai'i, which is characterized as having male and female components, had a profound influence on the group's creative inspiration. At Volcanoes National Park, the artists marveled at the active volcanism of Kilauea as they witnessed firsthand the actual creation of earth. And Pololu Valley, with its black beaches and lush tropical jungles, offered a wealth of materials with which the artists could work.

The sociopolitical movement of the Native Hawaiians became an important factor in the message of *This Path We Travel*. As in Canada, the native people of Hawai'i are striving for sovereignty. A movement is rapidly developing for the reclamation not just of territory but also of culture and cultural objects. As we listened to Kindy Sproat tell of the systematic loss of his family's traditional territory over the past three hundred years, we recalled Chief Snow's eloquent message about the rape of his people's Rocky Mountain territory at the hands of the state and the tourist trade. *This Path We Travel* includes tangible expressions of the common social and political struggles indigenous people encounter throughout the Western Hemisphere.

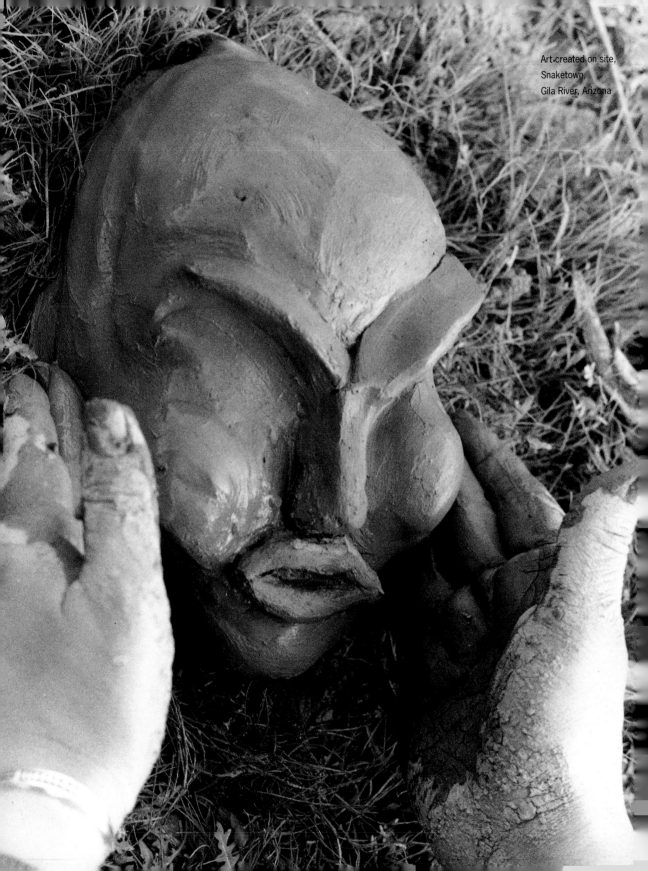

Art created on site,
Snaketown,
Gila River, Arizona

Even though the artists collaborated to articulate the traditions as well as the contemporary sensibilities of indigenous peoples, they did not always understand or agree with one another. Gender equality became an issue; the inherently different messages expressed by female and male viewpoints were, for instance, sometimes contentious. It was often difficult for the group to relate the traditional male and female roles of indigenous societies with these roles as they exist today. These widely varying interpretations meant the group had to compromise on how to represent these roles in the final installation of *This Path We Travel*. Hawai'i's native mythology relating to the environment, which features parity in male and female aspects of the landscape, informed our choice, and resulted finally in a collective decision to give equal distribution of space to both genders in the exhibition. The male and female areas of the exhibition, joining in the creation area, emphasize the significance and individuality of both sexes, as well as the joining of these forces to create new life.

The next meeting was in Phoenix, Arizona, where the group developed a collaborative statement that codified the exhibition process (see Appendix). The artists worked at the Gila River Indian Community where, through the generosity of tribal governor Tom White, the group was allowed access to Snaketown, a sacred territory and significant archaeological site. Gila River exemplifies the efforts undertaken by other indigenous peoples to assume control over access to a sacred site through negotiations with government and nongovernment agencies. The artists performed and made objects from the abundant natural clay on the shore of the Gila River: animal effigies, sculptures of earth mothers, and small shrines. All the objects were left to dissolve back into the earth—a statement reflecting our respect for the land and the fragile nature of human existence.

We believe there is an influence at each site that comes from the native people who live there today as well as from the spirits of the ancestors of that place. For the exhibition, the artists will reconstruct many of the objects that were created on site, so that the installation encompasses and reflects the ideas that affected the group at each place it visited. In this way, the artists will produce a completely unique exhibition experience—one that emphasizes the continuum of traditional to modern native art.

*This Path We Travel: Celebrations of Contemporary Native American Creativity* is our forum for reflecting on contemporary native creativity as a personal and a group experience. This book and the exhibition convey, in our own words, many issues we agree are significant to native peoples. As artists, we want to communicate that native artistic traditions have always provided a way to an understanding of our sacred traditions. *This Path We Travel* is a testament to the survival of indigenous innovation and tradition, despite overwhelming historical obstacles.

Notes
1. From *These Mountains are our Sacred Places: The Story of the Stoney People*. Toronto: Samuel Stevens, 1977.

*Lance Belanger is a Maliseet artist living in Ottawa, Canada. He has exhibited in numerous group and solo exhibitions in Canada, Europe, the U.S., and the Caribbean. He is currently working on art video projects in Costa Rica. Belanger has been content coordinator for* This Path We Travel.

# Emergence:
## The Fourth World

### Frank LaPena

*In the beginning, when all things were created and order had been established, or so it seemed, the world was changed several more times. As each world came into existence, it brought new beings and new dimensions. According to the Wintu, each change comes about because of greed or wrongdoing. The first world was destroyed by fire, the second by a big wind, and the third by a flood. We are now in the Fourth World.*[1]

*This Path We Travel: Celebrations of Contemporary Native American Creativity* expresses the concerns of fifteen diverse Native American artists about the world around us and how it is changing, and about the existence of future generations if the destruction of our ecosystem continues. These and other issues have influenced the art that grew out of this project. Some of what we have done is social commentary, while other works are our self-expression as contemporary Native American artists.

To agree on what we wanted to include in a collaborative project of contemporary Native American arts required that we clarify our objectives and adopt a mutually meaningful concept. Our diversity as a group made compromise necessary and the issue of design especially challenging. In order to provide the most opportunities for participation by all the artists—of the kind that took place over the course of the project—we decided to treat the final exhibition as an installation.

One of our major concerns was that many people do not have factual information about American Indians, Native Alaskans, and Native Hawaiians. We asked ourselves what we should tell the world about the indigenous people of this hemisphere. Our answer is in the installation—a collective public statement about our respect for the land, the spirit of contemporary Indian America, and about being Indian in an alien world. Prefiguring the installation is the collective journey of the imagination outlined in this book.

*This Path We Travel* is also about reclaiming our lost rights. In the old days, what is now New York City's Broadway was an Indian trail that ended at present-day

Battery Park and the Alexander Hamilton U.S. Custom House. During the more recent past, Indians were not allowed in Battery Park, as a fort was erected there to protect Dutch traders from the local Indians. In October 1994, the Custom House will be inaugurated with this and two other exhibitions as the home of the George Gustav Heye Center of the National Museum of the American Indian. This, then, is our return.

## The Four Sites

The philosophical underpinnings of this project centered on Native Americans' traditional views of the world as they are celebrated in ceremony and commemorated through prayer. The project has both sacred and secular aspects, as both are part of our experiences living in a world that is in conflict with our traditional ways. During the process we have shared over the last few years, we also chose to visit sites that represented the four cardinal points—north, south, east, and west—and held a ceremony committing ourselves to these travels.

Visiting the four sites helped us better understand the social and cultural mores of native cultures in this hemisphere. After initially meeting in New York, we convened in Morley (Alberta, Canada) on the Stoney Reserve, where ecumenical gatherings of native people were held between 1971 and 1980. A medicine wheel had been created for the gatherings on the high ground overlooking the Bow River.

One of the first objects the group created here was a sphere of natural vegetation. It represented the earth which, in Hopi legend, is balanced at the North and South poles. We built the sphere on the edge of the river, bridging land and water: We are of the land; and moving water is beneficial to the spirit, with a song all its own that inspires song in the listener.

While in Canada, we spent some time in the Grotto Canyon playing music and singing. Looking up the canyon's walls, with only a slice of sky visible at the top, made us feel small. We also went to Peyto Glacier outside of Banff, where the glacial runoff created fluvial sand deposits, giving the lake a pearly white shimmer. This was on the continental watershed between the Pacific and Atlantic Oceans at the headwaters of the North and South Saskatchewan Rivers in the Northern Waputik (White Goat) Mountains. We learned that this is where the Nakoda, also known as the Stoney, gather herbs and medicinal plants; the view was breathtaking.

Hawai'i, the second site we visited, was a place to celebrate earth and water, and the unique aspects of male and female counterparts in Creation. In Volcanoes National Park, the volcanism of Pele—the goddess of fire, daughter of Hauma (Earth Mother) and Wakea (Sky Father)—illustrated nature's power to create and destroy land, mountains, and forests. Halemaumau Crater was created by explosions of lava and water that showered the land with rocky debris. In contrast to the volcanic landscape, Pololu Valley was lush with green plants and flowers and alive with birdsong and the roar of a cascading waterfall. At Keokea Beach County Park, water-washed pebbles created a sound like a gourd rattle. Despite being surrounded by this beauty, we were painfully aware that both the tourist trade and the political climate have been extremely detrimental to the Native Hawaiians who, like their mainland native brothers and sisters, are struggling for sovereignty. They are currently dealing with issues ranging from rights of autonomy, to the sacredness of the land and the burden of commercialism, to the violation of sacred dance for the sake of tourism.

The twenty-five-hundred-year-old Snaketown site at the Gila River Indian Community just south of Chandler, Arizona, was our third site. Thanks to Tom White, governor of the Gila River Tribal Council, and to community members, we were granted access to this sacred place. By the flood-plains of the river and on the hillside, we created a rock cairn and rattlesnake, as well as clay sculptures. We danced and sang, accompanied by Pualani Kanaka'ole Kanahele's Hawaiian gourd and bamboo instruments, which made sounds like the earth, with deep and resonating roundness and wholeness. On our trip to Casa Grande Ruins National Monument, the elder Joseph Enos prayed in songs of the old times, like the bird singers of the southern California tribes. The women in the group did a hula dance in a moment filled with joy, seriousness, and pleasure.

Back in New York, where our journey began, we dealt with the business of organizing the exhibition that has evolved from this process. This eastern site is most important in that it is the one where the public will see and react to the installation we will create for the Heye Center. In each of the other sites, the actors in the group were able to create an on-site ceremony. Though we offered traditional prayers in New York, the creation of a ceremony will not take place at this site until the exhibition is opened. New York differs from the other sites, too, in that we did not spend much time with the Indians from this area, except for a brief visit at the community center, where we held some of our planning and production meetings.

Our experiences in each location, our different tribal traditions, and, ultimately, our roles as individual artists have influenced our expressions during this project, as has the necessity for collabo-ration, with the give-and-take this requires. As we

began to understand the importance and power of male and female roles in native societies, we were able to plan how we would portray our views of these roles in the exhibition.

## Traditional versus Contemporary Art

The art of American Indians reflects how their world changes. Ancient rock art depicts an abundance of game and birds, revealing the rich spiritual relationship the old ones had with the earth and the cosmos. Seasons and celebrations responded to the spiral path of life, which became known as the way of life—respecting all life forms and their diversity. But contact with Europeans changed this, introducing new situations and material goods into native societies. At first, some of these changes were easy to accept. As time went on, it became difficult to dismiss these influences. Art began to change.

During the mid to late 1800s, Indian people imprisoned for trying to protect their lands recorded their experiences in ledger art, a figura-tive style of art drawn on the blank pages of ledger books obtained from their white jailers. This paper and other new media, such as pencils, crayons, watercolors, and poster paint, helped refine the art and opened up new possibilities for artistic creation. Those who worked at this early time established the new order of art, which differed from the traditional art of pre-Contact times. The major difference was the development of art for art's sake, and the emphasis on individual creativ-ity and style rather than the communal aesthetics of the past.

The questions of outside influence are as relevant to Native Americans in these times as they were in the past. As we move into the twenty-first century, we know it is impossible to return to the old days. But what was good from the past should be

preserved. Indian artists are very much aware of a legacy of ancient art. As the creators of today, we use whatever is necessary to show us the truth for our times.

One of the more frustrating influences has been the emergence of a school of thought that labels the new style of art "contemporary" and the old style "traditional." These labels limit our appreciation and understanding of what each represents.

Every new movement or type of art is limited by the label contemporary. Though this label draws our attention to current trends, art styles, or artists, newer things are always being done and, of course, there are always new actors, singers, painters, and writers. Time in a linear sequence—past, present, and future—conflicts with the tribal notion of time. In native thought, everything is constant and part of existence from the moment it takes place. The circumstances may vary somewhat, but each new generation and season is part of the sacred circle of life. This difference in how time is perceived allows all events and issues to be accessible at any one time as subject matter for art or to gain perception of an issue.

## Creation

*If there were no symbols to express the force of life, other than its verbalization, I am sure artists would have to create them. This is our confirmation of our belief in ourselves and the sense that the past had a form and was visualized, and that we also need forms and symbols to understand our time now and in the future.*[2]

The Fourth World has become the beautiful place we know because it is a sacred, living entity. But as wonderful as the world is, it will not stay that way unless we take the responsibility to care for it. This symbiotic relationship provides reason and purpose

to life. If we do not accept our responsibility to care for the world, it will change for the worse. If the change is catastrophic, we may all have to start over, and knowledge of the natural world will again be of importance.

The balance of life on this earth and in the universe is represented in *This Path We Travel* by a circle and the symbols of Mother Earth and Father Sky. We open the exhibition with a theme that combines creation of the earth with creation of art. It is good to begin here, because this theme puts us in touch with the myths, legends, and archetypes of our beginnings. To understand that early time, the storyteller gave us knowledge about our cultural heroes and events of long ago. The creation of art gave life to the stories passed from generation to generation. The artisans, shamans, and ceremonies gave us carvings, paintings, music, and dance. The Creation area of

Art created on site,
Snaketown,
Gila River,
Arizona

the exhibition portrays the influences of both traditional and contemporary sources on artistic creativity in contemporary society.

The vital relationship of the land to people is represented in the Creation area of the exhibition by symbols of creation, such as earth, fire, air, and water; animals, fish, and fowl; and men and women. Symbolism helps us understand our place in the universe and cope with the mystery of things we cannot control. The ancient symbolism of the number four is reflected not only in the four parts of the exhibition—Creation, the Sacred, Profane Intrusion, and World View—but specifically in this area by four sculptures based on the creation stories of the people we visited. These sculptures connote the four cardinal directions, which make up the sacred circle of life.

Water, air, fire, and earth are fundamental to existence; the creation theme allows us to recognize the universality of human concerns and interests. The four elements become the flesh and blood of artistic creation and are realized by living things in the four stages of life: infancy, youth, maturity, and old age.

The Female and Male sections flanking the Creation area are joined by a spider web, symbolizing the trickster-creator of the Lakota, and the Navajo spirit-being Spider Woman, who gave threads from her body to be woven into what became the earth. The web also connotes the joining of male and female forces to create both life and art.

The Female area emphasizes the traditionally female arts of weaving and ceramics and makes a presentation of the vessel as a symbolic womb and a sanctuary for new life. The photographs of women displayed in this area indicate a legacy of presence and strength and illustrate roles both tender and

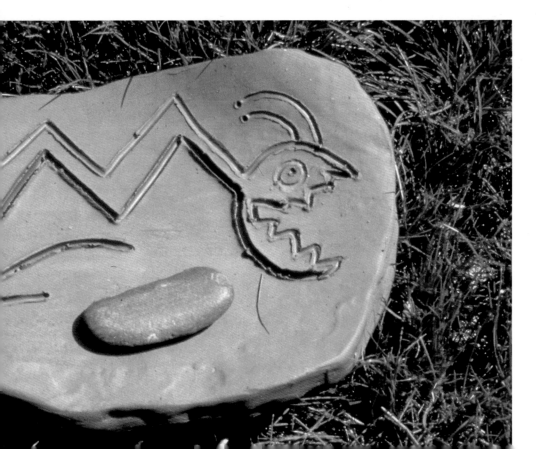

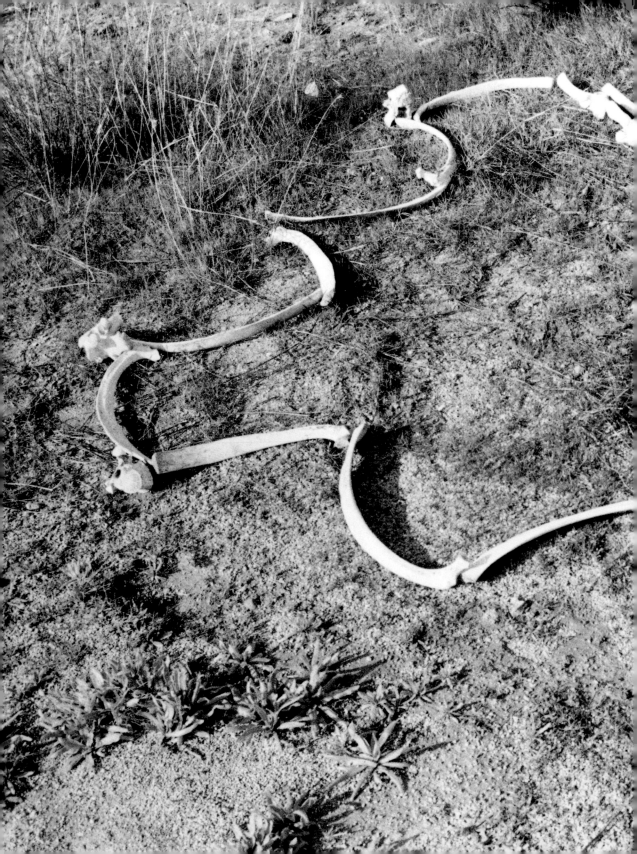

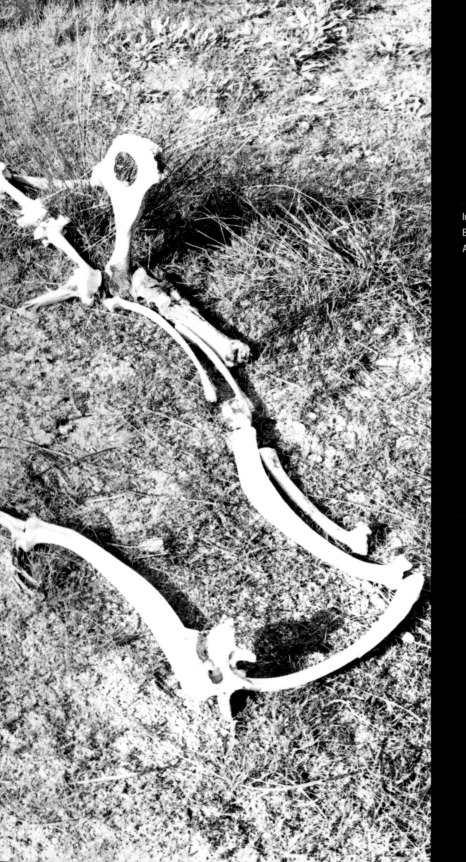

Installation,
Banff,
Alberta, Canada

powerful, from young girls to female warriors. The earth's moon cycle represents a woman's power to bear children. In the Creation area between the Female and Male sections, the two forces symbolically join to create life. In ceremonies and in most aspects of tribal life, male and female energies are used together to balance the way things are done. Both are important in the arts, healing, and teaching. In indigenous cultures, all peoples are valid and important to life. The elders taught us about the good from the past; as adults, we try to carry on the good by example and by creating new ways to guide our young in the present and in the future.

The Male area of the exhibition contains a grandfather pole, symbolizing masculinity and underscoring the connection between earth and sky. Native peoples of the Americas often use rock piles to represent sites of historic or contemporary significance. Built by travelers visiting a sacred place, these cairns are a physical representation and commemoration of our connection to the past. In Mesoamerica, cairns are called *apachetas*. An apacheta of the type we constructed with the guidance of José Montaño on a hill at the Gila River Reservation in Arizona will appear in this area of the exhibition.

All beings exist for a purpose. However, some—including the rattlesnake—embody particular significance for native peoples. In the Southwest, rattlesnakes are often used as design elements in artwork, and holy people interact with rattlesnakes in ceremonies that recognize the snake's right to exist on the land and be called sacred. Doug Coffin created a rattlesnake image that he originally envisioned as a thirty-foot-long design. Before he finished, though, the snake had grown to seventy-five feet, and we were visiting art stores and building supply outlets for materials to finish the

project. What made this task even harder was that Doug created his design going uphill, overlooking the highway and the Gila River. In the Male section of the exhibition, Doug's on-site creation is reconstructed in the form of a curving snake along the floor.

## The Sacred

*In order for human beings to maintain a relationship built on understanding and respect for the earth and for our own humanity, ceremonies are performed to remind us of our obligations. This is a commitment of choice. In ceremonies, both the spiritual and ordinary realms are present. In their connection they preserve and sustain the earth.*[3]

Moving from the Creation section to an area called Profane Intrusion, the visitor will pass through the

LeVan Keola Sequeira
and Dan Namingha
with cairn installation,
Banff, Alberta, Canada

Sacred area. On the floor will be the circular symbol for the universe. It will contain a cross representing the four sacred directions; each section created by the cross will be rendered in its own sacred color, and each will contain earth from one of our four meeting sites. The cross is a sacred symbol to both native traditionalists and Native Americans who follow the teachings of Christianity, though the configurations of the two crosses are different.

Native Americans hold that we are all sacred and that by the grace of respect we are allowed our differences. To restrict the freedom of others because of ignorance or prejudice means denying them a meaningful existence. We should be careful to remember, however, that in allowing freedoms, we do not permit violations of the sacred. This is something we hope to emphasize in the content and design of the exhibition.

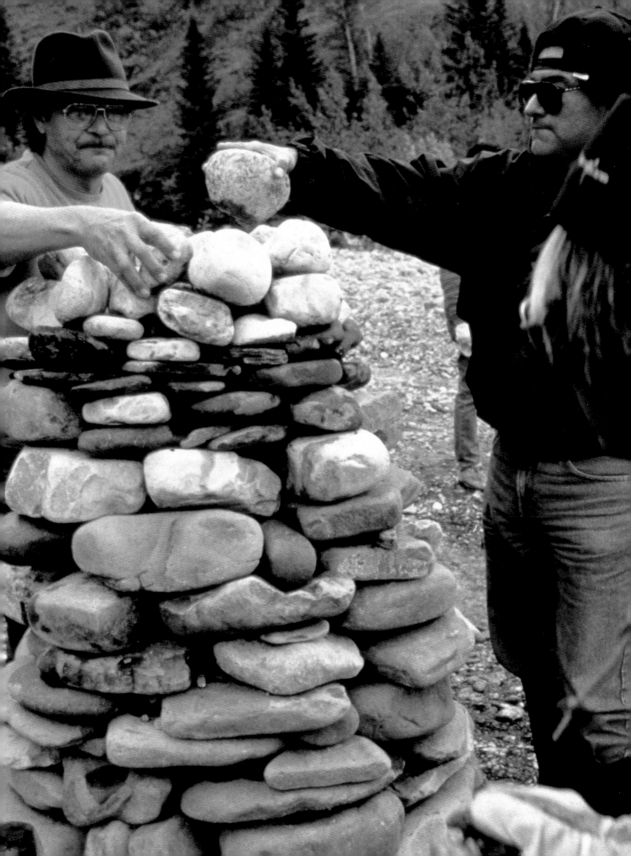

When the government wanted to eliminate Indian culture, laws and military force were used to control and stop indigenous religious ceremonies; native religious leaders were imprisoned. The confiscation of Indian land by the government was considered justified under the doctrine of Manifest Destiny. This attitude also explained the genocide and incarceration of so-called Indian troublemakers, often native religious leaders.

The persecution of those who practiced traditional indigenous religions has been omitted from most history books about the Americas. Stories about the California missions, for example, often refer to how the priests saved the Indians by giving them religion, teaching them to farm, and making them more "civilized." In actuality, the native peoples of California lived on the land for thousands of years with their own religious systems and achieved much before the intrusion of the Catholic Church. Without the forced labor of indigenous peoples, the mission system would have been impossible. Indians played important roles as builders of the churches and creators of the murals and decorations embellishing these sanctuaries. The missions' enslavement and abuse of the indigenous population caused the deaths of many California Indians. As the missions were secularized, the novitiates were left even more vulnerable to an unlawful society.

But the history of the California missions and indigenous peoples is not an isolated example of encroachment on our traditional sacred beliefs. As early as the mid to late 1800s, Indian children were taken from their reservations and sent to federal Indian boarding schools. These children were forced to accept a foreign language and belief system and, like many reservation populations, were subjected to proselytizing by various Christian churches. The disruption caused by tribal members turning to other religions and to non-Indian ways, along with

the loss of numbers of people to carry on our traditions, has made it easier for outside influences to affect Indian culture throughout history.

The relationship between traditional art and religion has always been personified by the shaman, either a man or a woman, as both priest and artist. Through the role of the shaman, sacred activities have always been interwoven with art. Because the Native American community is undergoing drastic changes in contemporary society, respect for both sacred and secular traditional activities has broken down. Consequently, the violation of sacred objects and sacred activities has increased. Today, many of our traditional sacred activities and symbols are being appropriated by self-made medicine people and New Age advocates. The distress caused by these changes may play a part in the high suicide rate and the prevalence of diabetes and tuberculosis among Indian communities.

This appropriation began in earnest in the 1960s, when young people and others drawn to the counterculture turned to traditional Indian ways as part of an alternative lifestyle. The New Age practitioners of the late 1980s and 1990s have gone even further, claiming for their own use native vision quests, sweatlodges, and even our sacred pipe ceremony. Some non-Indians have begun to call themselves medicine people and have taken Indian names. Such exploitation has sometimes been encouraged by Indian elders or false medicine men and women, who have sold these ceremonies for money and notoriety.

Today, American Indians must have a permit to gather eagle and other bird feathers, pelts, hides, and other items for sacred purposes. We believe these symbols should be restricted for use in our own ceremonies. Yet Indians and whites alike have violated this belief. In *This Path We Travel*, we

wanted to avoid displaying certain symbolic items like calumet pipes, special regalia, and featherwork. The Sacred area of the exhibition became a perfect place for artists to address what they regard as sacred and to interpret it, or to make a social comment on a particular issue. What constitutes sacred places—and what makes them so—is one kind of display. Arthur Amiotte offered to display a special pipestem belonging to his family, so it will be possible to show this sacred object, which will be used as a mnemonic device to teach traditional values. The sanctity of the pipe is most holy even without the bowl; the stem itself is of sacred value. It will serve to introduce us to the materials and symbols that direct us to the special powers of the earth.

*The world is a gift from our old ones. This sacred gift was created through love and respect by those elders who understood the beauty of their surroundings. Their understanding encompassed the total meaning of life within their environment. The old ones paid close attention to the sacred earth and to all nature. They were involved with the mysterious and magical dimensions of reality. . . . The power of knowledge was revealed to medicine people and traditionalists involved in its pursuit. We respect those thoughts and teachings and when we are forgetful and need reminding of those teachings they are given back to us in our dreams. Those whose responsibilities are dreams give us prophecies and answers on ways we should live and think. These dreams direct our actions, give dimension to our symbols, and extend the meaning of life. What has always been true is still meaningful; although it may change through time, its essence is always the same.*[4]

This sentiment is shared by the indigenous peoples of this hemisphere. Within the respective territories, the traditionalists know every part of the land intimately and attribute special sacredness to unique landmarks and natural configurations. They may limit their activities in some areas and avoid others entirely. To the white man, the land is not held sacred but is regarded as a commodity with commercial value.

As the land was settled and changed by development and by the destruction of indigenous people, American society lost the land ethic, knowledge, and mystery about the land that the native people had developed over countless generations. Not only were we named for the land, but our connection to it created the concept of a homeland.

History as written by non-Indians has often disregarded or misunderstood our reverence for the land and denied the accomplishments of Native Americans. Publishers and historians often leave out those parts of history that involve indigenous people and their contributions to society. This is changing with the introduction of publications such as *Keeping Slug Woman Alive* by Greg Sarris, and the journal *News from Native California*, which publishes the work of contemporary native writers. However, most histories tend to overlook recent contributions by Indians. They often do not mention, for example, that even though Indians were not legally citizens of the United States at the time, they were willing to sacrifice their lives to protect their country in World War I.

Many people choose to ignore contemporary American Indians' involvement with the land. Writing about northern California's Shasta Mountain in his book *Sacred Mountains of the World* (1990), Edwin Bernbaum illustrates this point, claiming "local tribes who had a connection to Mt. Shasta had largely vanished."[5] He also states that there has been a revival of interest in the mountain by contemporary tribal groups. He does not bother to talk to the Indian

people about his ideas, which are erroneous. My own Wintu tribal members have always followed the sacred practices that connect us to the mountain—practices that began long before any white man ever set foot in this part of the country. Other tribes in the area also have a long-standing relationship with the mountain.

The American Indian Religious Freedom Act of 1978 reaffirmed and mandated the protection of the religious rights of Native Americans. Why did Indians have to wait until 1978 to gain the freedom of religion that is assured U.S. citizens under the Constitution? Just ten years later, in 1988, the U.S. Supreme Court denied religious freedom to the indigenous people of several northern California tribes by restricting their access to and use of a known sacred site that was integral to their religious practices. These and other events in the history of Indian-white relations in the United States remain in the collective consciousness of Native Americans.

One of these events is the 1890 massacre at Wounded Knee Creek, South Dakota, in which nearly four hundred Lakota men, women, and children were killed in the government's attempt to suppress the practice of their religious beliefs. That the government awarded numerous medals to troops responsible for slaughtering unarmed Indian men, women, and children (more medals were bestowed upon the troops for the massacre of the Lakota than for any other military action in U.S. history) says something about the lack of value placed on native human life at that time. The killing of so many innocents is a reminder of the price indigenous people of the Americas have paid for religious freedom. In Central and South America, native people are still being slaughtered in the 1990s on behalf of progress and technology.

The world view of an integrated rather than a fragmented life makes one accountable for the past, present, and future world. To Native Americans, all times are of one existence. What we have had to give up and what has been taken away from us has hardened some of our reactions as we try to preserve what we still have. On several occasions, for instance, it has been suggested that a group of Indians raid the graveyard in a community and dig up some of the founding fathers to teach mainstream society a lesson. I believe this would be counterproductive because it is based on the erroneous premise that non-Indians care about their dead, whereas the opposite seems true. There have been stories in the press, for example, about graves being dug up so that science can prove a point. The most recent example was the 1991 exhumation of U.S. President Zachary Taylor in Louisville, Kentucky, to determine the cause of his death.

The mass media have also exposed violations to cemeteries where people of all races are buried. In one notable case, a sheriff's deputy was caught looking for Indian artifacts in the northern California Paskenta Indian burial grounds in 1977. The public's interest in archaeology, beginning with Thomas Jefferson's first efforts in this field, has continued to thrive; and people are still curious about—and collect—Indian artifacts. The situation has become so bad that people are unaware they are doing anything wrong. Museums continue to exhibit objects from the graves of our dead, ignoring the history of desecration that it represents.

### Profane Intrusion

*Part of tradition is tied to a natural world which is being destroyed. If we are not worried about the Apocalypse, getting killed in the streets, or having*

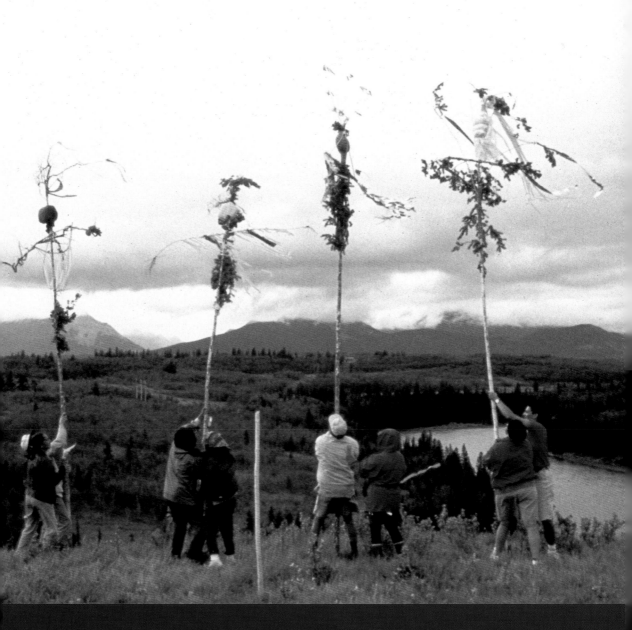

Artists with effigies,
Stoney Reserve,
Alberta, Canada

*the drug culture undercut our lives, we might*
*wonder what kind of world it will be in the future.*
*It is hard to live with all the stress, worry, and*
*change that modern technology imposes on people.*
*It is hard to maintain traditions in such circum-*
*stances. Our world is not the world of our great*
*grandparents.*[6]

How much have we as native people given up to
participate in the urban lifestyle, and in what
way has materialism shaped our actions? Do we
have the choice to live a more traditional way
and, if so, what must we surrender if we want to
be Indian? The effects of having to fight for the
most fundamental right of freedom of religion,
along with the violations of traditional values by
force and by laws governing our moral rights, do
great harm to the psyche and civil rights of
Native Americans.

We have been transformed by five hundred years
of living with Euro-Americans, African Ameri-
cans, and Asian Americans. The fragmentation of
our lives into vocational, leisure, religious, and
secular activities further disrupts Native Ameri-
cans' traditional belief in a holistic approach to
existence. Our philosophy revering the sacred-
ness of the land makes the loss of it much more
devastating. Rights that protect tribal land have
been violated by laws that take away the land,
further impoverishing our people.

### Land
The sacredness of land was established during
Creation. The land was created as a living entity
with a spirit of its own. Native American oral
tradition holds that as each world was destroyed
and a new one created, each tribe found its place
in a way that connected it to certain mountains
and other geographic features. The stories not
only validated the connection between humans

and the land, but reminded us of this timeless
link. Colonialism forced a change in the relation-
ship of the Indian to the land.

American expansion was dependent upon the
removal of Indians from the land, resulting in a
policy based on Manifest Destiny, by which the
Americans felt that it was God's will that the
Indian nations should be vanquished. The loss of
Indian territory in the United States is the direct
result of a political system that was imposed upon
native nations, and which ignores our right to the
land. Reservations for Indians were established as
early as the eighteenth century. This exploitation
was later exemplified by the Indian Removal Act
of 1830. Systematic removal of eastern Indians
to the West culminated in the Trail of Tears, the
tragic forced migration of Choctaw, Cherokee,
Creek, Chickasaw, and Seminole peoples from
their southeastern homeland to the Oklahoma
Territory from 1831 to 1839. This launched the
diaspora of the southern tribes and resulted in
great loss of life. Public outcry should have
stopped such injustice, but there was only
silence, and the belief by many whites that the
"Indian problem" could be solved by confining
Indians to one location, where they could be con-
trolled and out of the way. The public accepted the
removal of all Indians west of the Mississippi River to
Indian Territory (now Oklahoma).

Earlier exploitation of Indian lands was justified by
the passage of the Northwest Ordinance of 1787,
which allowed much Indian land to be taken. The
government-sponsored land rush into the Okla-
homa Territory after oil was discovered in the late
1880s broke the promise that Indians would have a
protected sanctuary of their own. To make things
worse, the General Allotment Act of 1887 (known
as the Dawes Act) divided land that was once held
in common by Indians into individual plots that

could be bartered away. As a result, over eighty million acres of Indian land passed into non-Indian hands by 1934, when the act was rescinded.

Reservations, *rancherias*, and reserves—usually established on the most useless land—struggled for existence against the ever-expanding white world surrounding them. In addition, because of the isolation of Indian lands, it was almost impossible to get proper health, welfare, or educational services to those who lived there. While the tribes were being squeezed onto smaller parcels of land, they were treated as domestic dependent nations and, by the late nineteenth century, as wards of the government. Under President Ulysses S. Grant, the government and churches adopted a paternalistic attitude and divided the education of Indians among various Protestant religious groups. Christianity was considered the only way to save the Indian. In 1867, under Grant's Peace Policy, a commission comprised of members of the army, Congress, and civilians was established to continue Indian relocation onto reservations and to force assimilation of Indians into white culture.

The alien, profane world has also violated the lives of Indians in the form of the trusteeship of the Department of the Interior's Bureau of Indian Affairs (BIA). The bureau serves two conflicting purposes. Because it is in the Interior Department, the BIA is responsible for the environment and its uses on Indian lands, as well as for protecting the rights of Indian people. When choosing between safeguarding these rights or promoting the exploitation of the land, though, the BIA has usually allowed profit to take precedence over people.

### School Room and HUD House
The Profane Intrusion section of the exhibition includes an Indian boarding school room that addresses the contradictory, sometimes racist, forces at work in our educational system: white education plays a role in enabling our children to cope with Western society, while inherent racism in that educational system was once used to indoctrinate young Indian children, teaching them to abandon the legacy of their Indian heritage. As a result of forced assimilation, many Indian children were taken from their families and put into BIA boarding schools; military force was used to squelch family resistance to this process. At the same time, Christian churches were deployed to proselytize Indian communities to Christian beliefs.

Religious institutions and boarding schools were intent upon separating children from their families, believing that this would prevent young people from learning about their tribal history, culture, and traditions from their families and tribal elders. As recently as the 1940s, Indian children caught speaking their own languages in the schools received corporal punishment or were sometimes made to eat lye soap. Many tried to run away and were punished when apprehended. It was possible for a child to be put into the first grade and never live with his parents again. Until the time they graduated from high school, students had very little opportunity for contact with their families. By the time they left school, many no longer fit into the reservation lifestyle. The training in the Indian schools was vocational rather than academic; Indians were not considered intelligent enough to go to college.

The strength of the Catholic Church in the Southwest and in Central and South America attests to its success in destroying native cultures. Frequently, political and religious exploitation under the Catholic Church were one and the same; there was no separation between religious and political interests. In California, many tribes were displaced and dispersed

Rock installation,
Snaketown,
Gila River, Arizona

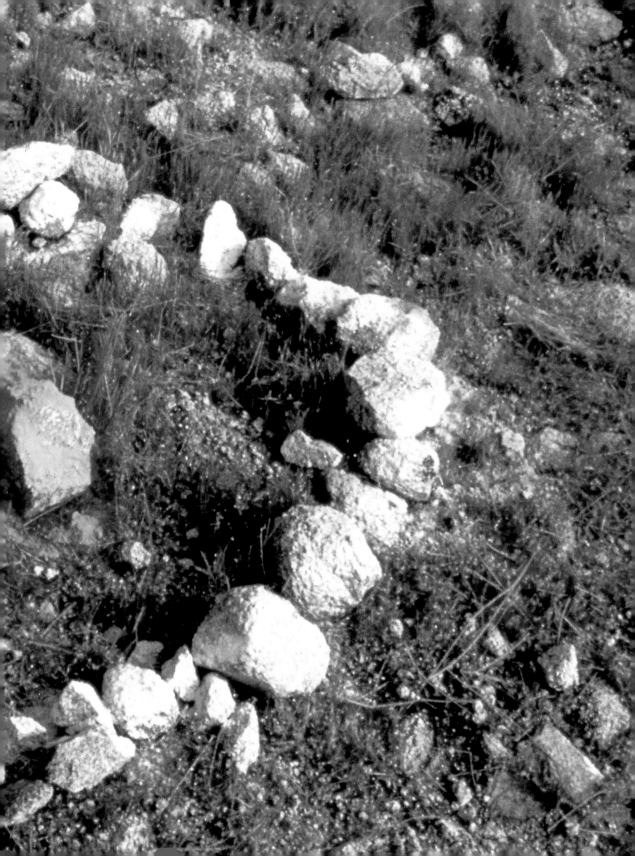

by disease and the genocidal practices of the priests and garrison troops of the mission system, the miners of the gold rush, and settler-vigilantes. Between 1800 and 1910, the California Indian population dropped from 333,000 to 20,000.

In the Profane Intrusion section of the exhibition, the reservation today is represented by the type of house built by the Department of Housing and Urban Development (HUD) for Indian people. With its commodities and pop art sculpture, the HUD house is a stereotype that points out the materialistic trap in which many are caught. At the same time, it pokes fun at us for falling for such a joke. Unfortunately, some of us live—not always by choice—in homes quite similar to the HUD house. And some of us live in old cars, in sheds, or on the streets of unfriendly cities, displaced in our own homeland.

## Indian Reorganization Act

The Indian Reorganization Act of 1934 gave Native American governments more autonomy, but undercut traditional leadership by organizing the tribal councils under a non-Indian model. During this period, the United States began to rethink its approach to Indian education. Indian art, however, was finally beginning to be recognized as a way to educate Indians and as an emerging economic force. Previously, native arts were forbidden in boarding schools; however, native arts, such as painting, were encouraged and soon flourished during the 1930s in The Studio at the government-sponsored Santa Fe Indian School. The focus of the painting was on everyday scenes that the young students remembered from their communities. At the same time, museum scholars began to encourage such artists to document ceremonial scenes for the sake of their own anthropological studies. Indian artists were commissioned to paint murals on public buildings as a way to foster this style of art and encourage the students to stay in school, and artists like Allan Houser

(Apache) and Oscar Howe (Lakota) began to receive the recognition they deserved. They also became even more creative and expanded their art beyond the preconceived notions of what Indians should paint. Hulleah's father, Andrew Tsinhnahjinnie, was part of this leading group of contemporary Indian artists.

## Burials

A continuing concern of Native Americans is the violation of sacred places, including burial sites and their associated goods. The Antiquities Act of 1906 made illegal the excavation, appropriation, or destruction of objects of antiquity found on lands owned or controlled by the U.S. government. Despite the law's intentions, the protection of archaeological sites did not always work. Grave robbers had to be caught in the act, and the thousands of unpatrolled archaeological sites made this very difficult. In addition, the penalties were so low that those caught could afford the fines because of the high prices paid for the illegally removed artifacts. And the law did not protect Native American communities frequently confronted with violations of their grandparents' and great-grandparents' graves, or of graveyards that are currently in use.

The Native American Graves Protection and Repatriation Act (NAGPRA) was passed in 1990 to provide a method by which Indian people could reclaim burial materials held by public institutions. Passage of the act concerned collectors, dealers, and museums, who feared that all Indian artifacts would be taken from them. But this is not the intent of the law. Along with the 1989 National Museum of the American Indian Act, which legislated the creation of the new museum, NAGPRA codified a policy for the repatriation of American Indian and Native Hawaiian human remains and associated funerary objects. The law also stipulated a timetable for a process of invento-

rying, identifying, and notifying tribal groups, and for the repatriation of Indian remains. Passage of these bills reflected the concern and work of many people. The intent of this legislation was to correct wrongs. It was not aimed at removing all Indian artifacts from public and private collections, but only those items associated with burials, and objects that are considered sacred and important to the continuation of native religions.

Some tribes have gone on record stating that there should be no disturbances of any kind to Indian lands, whether they are burial or other kinds of sites. Because of population expansion and the associated need for new housing and commercial projects, it is increasingly possible to disturb a burial or village site accidentally. It is incumbent on developers to contact the proper tribal groups to help with reinterment or decide what should be done. But this does not always eliminate or prevent unfair, immoral, or unethical practices. For example, in 1985, a recorded archaeological site in Redding, California, was violated and the developers were pressured to stop their activities. When the review team came the next day, there was a big pile of dirt from which human bone fragments obviously protruded. Nonetheless, the developers claimed no burial site existed. They got away with this because there was no grading ordinance in Shasta County. It is sad when legality takes precedence over morality. On another occasion, a tribal council called a local television station to film people digging in a known Indian burial ground. When confronted, the grave robbers claimed they did not know the site was a burial area. At the time, some Indian people suggested shooting grave robbers and leaving them at the grave sites.

### Government Intrusions in Native American Art
In 1990, a bill was signed by Congress that classifies American Indian artists based on legal tribal affilia-

tion. The Indian Arts and Crafts Act provides that an artist claiming to be Indian must be enrolled as a member of a tribe with federal or state recognition or be certified by one of these tribes as an Indian artist. This has been a very controversial piece of legislation because many of the well-known "Indian" artists could not offer such proof of their claims. Others see it as simply another intrusion into the lives of Indians. Classification according to blood quantum or tribal registration has been one of the plagues of being a Native American in white America.

The idea behind the passage of the Indian Arts and Crafts Act was that there were just too many "fake" Indians in the art field whose success was taking money out of the pockets of real Indian artists. Senator Ben Nighthorse Campbell (Cheyenne), who is also a well-known native artist, was one of the bill's sponsors. In Herman J. Viola's 1993 biography of the senator, Campbell declared:

*If an artist is proud of advertising that he is a specific kind of Indian, then he should have no problem tracing his background, even if he is not enrolled. On the other hand, if he cares so little about his heritage that he never has anything to do with the tribe from which he claims to have descended except to use it as a marketing ploy, or if the only way he can get his work sold is by advertising that he is an Indian, then he should not be validated. There are a great many artists out there doing Indian art, but good art should be able to stand on its own merits and not need the words "Indian-made" to prop it up.*[7]

There is money to be made in the Native American art scene, but it is certainly not in the fine arts area. The big money is made in the trade of artifacts. An excellent basket or traditional mask can cost more than four or five paintings. The Arts and Crafts Act has eliminated some of the

fake Indians, but has been much more destructive to legitimate Indian artists. Indian artists are never given due process, because the general public believes that there is only one way to prove one's Indianness, when in reality there are many ways to prove oneself. Part of the fear stems from the $25,000 penalty imposed on violators of the law. Instead of risking this possibility, galleries often find it easier to simply avoid showing the work of Indian artists.

Being Indian is not a guarantee that an artist's work is worth buying or exhibiting. Merit lies in the quality of the art, and the duration of the artist's vision over a number of years. Each of us is female or male, Indian or not Indian, by nature—not by choice. If the work is no good, labels are not going to help.

## World View

A most profound and disquieting realization is that, as bad as things have been for the indigenous people of this hemisphere, contemporary society is becoming more dehumanizing to the spirit, and Indians have been the guinea pigs in this socialization process. And just as unjust and legalistic actions have disenfranchised Native Americans, materialism and technology have had an impact on the world's natural resources and affected our potential to be sensitive and caring about each other. Elders warn that when people lack respect for others and life in general, that is the beginning of an insensitivity to all life that will bring harm to other nations, to our neighbors, and eventually to our own sons and daughters.

In the World View section, there is a burial scaffold from which a child is suspended to remind us of the world's desperate circumstances and of our need to think about the future. It brings to mind the question: Will we, by our actions, allow this child to retrieve the creative energies of tradition and accomplishments of society? Or will we allow this vision to fall through as this world approaches the Apocalypse? These are questions that nations and individuals must answer.

Tradition teaches that all things are related and bound together in a sacred circle. The same sentiment is expressed by the saying, "No man is an island." Mass media have made this even more apparent. In the old days, when other nations and people were distant and "different," and when populations were devastated by natural disasters like hurricanes, floods, fires, and earthquakes, it took many days or weeks for the news of these mishaps to spread. Now, television and other electronic technologies have made the world smaller and news more immediate. The sacred circle as a philosophical vision in the exhibition symbolizes our awareness that others suffer hunger, pain, and sorrow; that they experience joy; and that life and death are universal. And regardless of the nation or state, individual citizens are like us, with human needs and weaknesses.

Technology is no panacea. It has drawbacks that can be harmful to life. While nuclear development has been beneficial on some short-term projects, where do we put the contaminated waste? All of life, from the simplest to the most complex organisms, will be affected by how we solve this problem. In addition, where do we put the byproducts resulting from the materialism and consumerism of developed nations? What are the consequences if we continue to exploit the resources of Third World nations? We cannot continue the practice in this country of using Indian reservations for dumping grounds. Power is neutral; it can be used for good or for bad. Nations and individuals who have access to

power need to consider the long-term consequences of exploitation of natural resources. When the air, water, and land are contaminated, no one will be able to escape the destruction.

By their very nature, artists are continuously contemplating, analyzing, reacting, and creating. Artists are agents of change. As the sacred circle taught a united vision to tribal societies, it was the artists who first realized this vision. By showing how to integrate the present with the past, artists are not always understood. But their ability to be flexible and accommodate change makes art relevant, current, and vital. Like the work of its artists, a dynamic and living culture is also flexible and aware of choices. This is its key to survival.

*Notes*

1. From a presentation by Frank LaPena to the College Art Association, Chicago, 1992.

2. Frank LaPena, "Rights and Symbols," *News from Native California* 6, no. 2 (spring 1992).

3. From a presentation by Frank LaPena to the College Art Association, Chicago, 1992.

4. Frank LaPena, *The World Is a Gift* (San Francisco: Limestone Press, 1987).

5. Edwin Bernbaum, *Sacred Mountains of the World* (San Francisco: Sierra Club Books, 1990).

6. Frank LaPena, "Sharing Tradition," *News from Native California* 4, no. 1 (fall 1989).

7. Herman J. Viola, *Ben Nighthorse Campbell* (New York: Orion Books, 1993).

Effigies, Hawai'i

# Artists'
# Statements
# and
# Biographies

# Arthur Amiotte

*Arthur Amiotte (Oglala Lakota) was born at Pine Ridge Reservation, South Dakota. He has studied anthropology, art, and religion and has traveled throughout the United States and Europe researching museum collections on northern Plains Indian art. He holds a bachelor's degree in education from Northern State College in Aberdeen, South Dakota, and a master's degree in interdisciplinary studies from the University of Montana. Much of his time has been spent as an apprentice to elder native tribal artisans and religious leaders to learn traditional arts, crafts, religious beliefs, and sacred ceremonies of the Lakota people. He in turn has been a mentor to several young Oglala Lakota students of sacred traditions and arts.*

My early experiences of "real culture" began with my grandparents. My art makes a statement about native existence—not of a mythical, romantic Indian riding across the Plains, but rather the story of the Indian today who was born into a reservation home. For example, we lived in a log house on the reservation, drank water from the creek, and made *wastunkala* (dried corn) and dried berries for *wojapi* (pudding). We were allowed to experience life through all the senses, growing into the age of reason, where one is able to understand as an adult the true meaning of things.

I was raised by my grandparents, because my father was in the service and my mother had to work off the reservation at the Ordinance Depot in Igloo for the war effort. My early bonding with my grandparents and the elders on the reservation instilled in me the consciousness of belonging to a group. Even as a boy, I helped with the chores of gathering roots and berries and hauling wood, and I helped sort beads for the bead-makers. Those six years with my grandparents have influenced my entire life.

When my parents moved to Custer, South Dakota, I joined them and started the first grade. In school, I became aware of the differences between Indian and white culture. In Custer, focus on the individual seemed to be the norm, rather than focus on the community. On the reservation, aunts, uncles, cousins, and neighbors all shared the same value system and would help each other. I also noticed a feeling of competition—an emphasis on being better than someone else. Back home on the reservation, we'd have footraces and compete against our cousins in horse riding and tricks, but the emphasis was placed on being good, not on winning over someone else. Fortunately, I could return home to my grandparents during the summer, where my cousins and I enjoyed the days and were lulled to sleep at night by the storytelling of the elders. As

soon as it was dark and the cows were in, my grandparents would lie in their beds and tell stories, changing voices with the different characters. We grew up with a strong sense of having seen a fantastic world through those stories.

Mine is a family of Indian intellectuals. We examine the nature of life through ceremony, vision quest, mythology, and our history. My focus on art intensified when I attended a summer workshop taught by Oscar Howe at the University of South Dakota in Vermillion. I adapted my style of artwork after Howe but also incorporated scenes and figures from my experiences at Pine Ridge. Most of my works were interpretations of nineteenth-century life and themes based on Lakota mythology and legends.

After earning undergraduate and graduate degrees and training in traditionally Western forms, I apprenticed with elder tribal artisans and religious leaders in order to learn the techniques of traditional arts and crafts and Lakota religious beliefs. From 1972 to 1981 I studied with a holy man on the Pine Ridge Reservation learning the sacred rites and ceremonies of the Lakota people. I recall that four years were spent in formal learning and the rest of the time I actually assisted in the ceremonies. I wanted to find out what makes "Indianness" persist. I wanted to know the secret information of religious tradition. So I continued my education in this traditional Lakota mode. I studied the mythology of my people, the sacred rituals and metaphysics.

I feel like an ambassador on behalf of the Lakota and for the traditional arts of Native Americans. I want to give back to the community, in the tradition of sharing and giving that I learned as a child. I would like to be known as an artist, not

just an Indian artist. Teaching, lecturing, and artwork have been important to me; I have been devoted to them. I like to think, however, that I'm also a "good Lakota man," and that these are simply things I do.

I enjoy the conceptualization that takes place in a collaborative project like *This Path We Travel*. I've always worked collaboratively and cooperatively with students in designing exhibitions, and I'm also familiar with the collaborative experience of ceremonial preparation; the process is not new to me. In fact, I see it as a natural extension of how Indian people should be able to operate.

In traditional ceremonies, we go back in time and start at the creation of the world, and then proceed through mythological and sacred time to arrive, once again, where we started. It's a cyclical kind of journey. It's a theme that also runs through the exhibition, and I find it quite exciting. Ceremonies remind us of that process—not as individuals, but collectively as a whole people—of moving from the very origins of the universe and this planet to where we are now. That's a continual mode or way of looking at the world. We're constantly involved in that process.

Arthur Amiotte,
Snaketown,
Gila River, Arizona

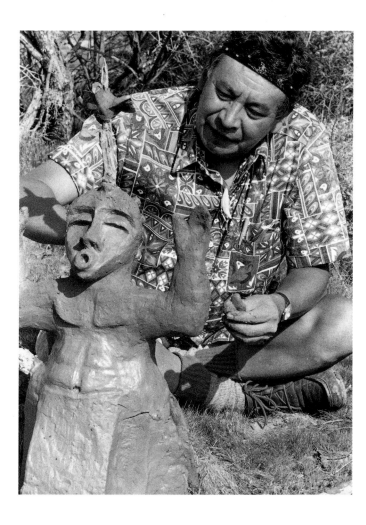

# Arthur Amiotte

## Exhibitions

✪ *Visions of the People*, Minneapolis Institute of the Arts, Minneapolis, 1992–93

✪ *Native America: Reflecting Contemporary Realities*, Los Angeles Craft and Folk Art Museum, Los Angeles, 1992

✪ *Red Cloud International Exhibition and Competition*, Most Innovative Artist Award, Pine Ridge, South Dakota, 1990

✪ *Plains Indian Arts: Continuity and Change*, traveling exhibition organized by the National Museum of Natural History, Smithsonian Institution, Washington, D.C., 1987–90

✪ *Voices of Today: Cultural Expressions of Native People of North America*, traveling exhibition, American Institute, Bozeman, Montana; Nippon Club Gallery, New York; The Triangle Native American Society, Duke University Museum of Art, Durham, North Carolina, 1986

## Publications

✪ "Eagles Fly Over," "Our Other Selves," and "The Road to the Center," reprinted in *I Become Part of It*, edited by D. M. Dooling and Paul Jordan Smith. New York: Parabola Books, 1989

✪ "An Appraisal of Sioux Arts" in *An Illustrated History of the Arts of South Dakota*, edited by Arthur Huseboe. A centennial project sponsored by the South Dakota Council on the Arts and the South Dakota Committee on the Humanities. Augustana College, Sioux Falls, South Dakota: Center for Western Studies, 1989

✪ "The Contemporary Vision Quest of the Oglala Sioux" in *Native American Traditions: Sources and Interpretations, An Anthology*, edited by Sam D. Gill. Belmont, California: Wadsworth Publishing Company, 1983

✪ Foreword to *The Sacred Pipe: Black Elk's Account of the Seven Rites of the Oglala Sioux*, illustrated edition, edited by Joseph Epes Brown and illustrated by Vera Louise Drysedale. Norman, Oklahoma: University of Oklahoma Press, 1983

✪ *Art and Indian Children of the Dakotas*, a five-volume series of bicultural textbooks for Sioux elementary students, BIA, Aberdeen area office, 1970–75

Arthur Amiotte,
Snaketown,
Gila River, Arizona

Sculpture by
Arthur Amiotte,
Snaketown,
Gila River, Arizona

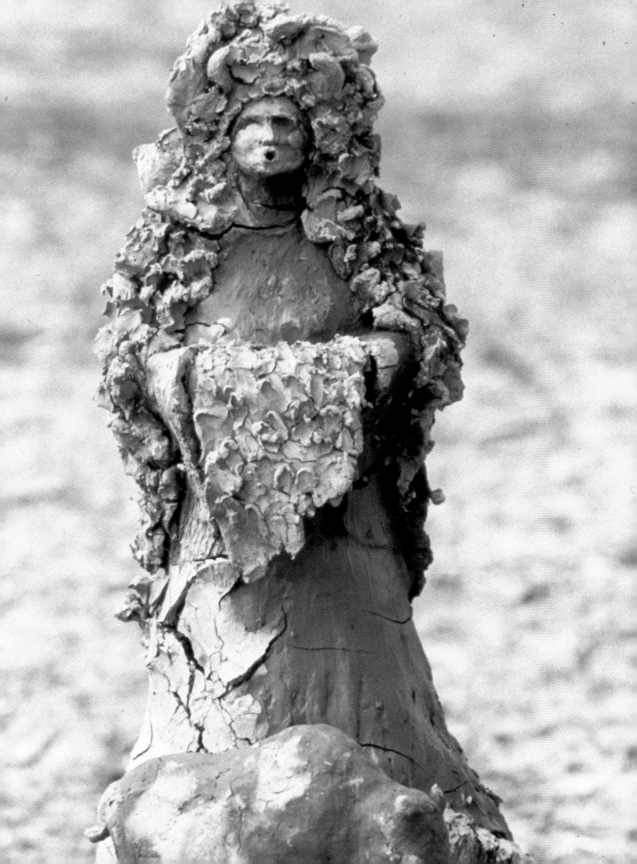

# Douglas Coffin

Douglas Coffin (Potawatomi–Creek) is a well-known artist whose monumental sculptures have been exhibited both nationally and internationally. Coffin, who works out of a studio in Abiquiu, New Mexico, cites "power objects," such as Northwest Coast Indian totem poles and Plains Indian shields, as inspirations for his art. He has exhibited his traditionally inspired paintings and sculptures, which combine high-tech materials and natural elements, at the Heard Museum in Phoenix, the John F. Kennedy Center for the Performing Arts in Washington, D.C., the Wheelwright Museum and galleries in Santa Fe, and the Museum of Civilization in Ottawa, Canada. He has taught at both the College of Santa Fe and the Institute of American Indian Arts, Santa Fe.

When I was young, my father taught at Haskell Institute in Lawrence, Kansas (which became Haskell Indian Junior College and later Haskell United Indian Nations University), the first four-year college for Native Americans in existence. There were native people at the school from all over the country, and I was exposed from an early age to traditions not just from my family's people, but from many different cultures. In graduate school, I realized that I couldn't really relate to the art of the classic periods that I had studied as a jewelry and sculpture major in undergraduate school, and I started researching Native American artifacts and objects. I began to feel a connection to objects that had been created for ceremonial or ritual purposes—certain power objects like totem poles and shields.

The first time I showed any sculpture was seventeen years ago, when I moved to New Mexico. The piece was a twenty-four-foot contemporary totem made out of wood. Generally, my totems are over twenty feet tall, sometimes as tall as forty feet. In an effort to make a contemporary statement while drawing from traditional sources, I often use steel and contemporary materials in my work. For example, instead of the animals found on traditional totems, I use brightly colored geometric forms.

Contemporary native art is considered "new" because it's being done now. But it's a continuous thread that has never actually been broken. Although Native American cultures have been suppressed, the art associated with these cultures has never died. The art is new, but it still has a very strong thread connecting it to the past. Native people have incorporated outside influences into their work whenever possible to make their lives more efficient or better. And no matter what materials or techniques they use, they try to make their creations beautiful. They are able to transfer their traditional values onto new materials, and into

new methods. For example, the ledger art created by imprisoned Indians in the late nineteenth century was a new form of art, using materials the artists had never used before—ledger paper, crayons, and pencils—because that's all they had. The key is that they continued to express themselves, imparting their spirituality and philosophy to their work, despite the situation in which they found themselves. Their art was a life force that endured, although it wasn't considered "art." Making things beautiful was just considered something one did with one's life.

Installation by
Doug Coffin,
Gila River, Arizona

In our travels for *This Path We Travel*, we have encountered such powerful forces as the Canadian Rocky Mountains and the Pacific Ocean. We were inspired by these forces, and the messages in the exhibition reflect their influence. Although the forces of nature cannot be boxed, some of the sensibilities, feelings, and power we experienced at the various locations are conveyed in the exhibition, in a sense "relocating" nature to the exhibition space.

Interaction with the native people in the areas we visited also provided a driving force for the project. Interestingly, in locations as distant as Canada, Hawai'i, and Arizona, many of the people had similar concerns, such as loss of land and lack of religious freedom. In this country, materialism has led to greed, and the first thing people want is land.

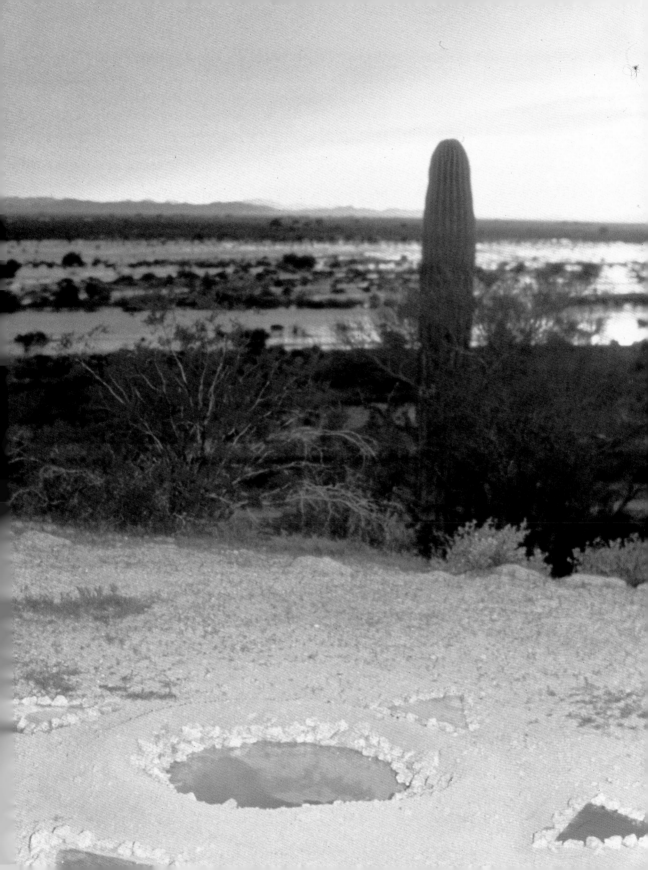

But there are native people on the land, so others who want land have to figure out how to get rid of natives one way or another. Once a native culture is destroyed, the dominant culture can easily gain control, because there is no unified body to resist. This may be "the land of the free," but history demonstrates that religious and other freedoms are apparently only for the people who have the power. Greed has also contributed to the destruction of Mother Earth, this planet on which we all live. We address these and other concerns, focusing on respect for the land and for our fellow humans, in *This Path We Travel*.

The sacred and the profane are two more elements addressed in the exhibition. In my own art, these themes sometimes appear in an abstract way. For example, I once used "Crazy Horse" beer, a particularly offensive product name, as a focal point of a show. Crazy Horse was a native spiritual figure and a leader of his people. If a beer were named after Buddha or Jesus, it would never be tolerated, and this is an illustration of a common problem: lack of respect for native thoughts and beliefs, and a general ignorance of indigenous cultures.

I hope that *This Path We Travel* will heighten awareness that native traditions are alive and well in many areas of this land; a lot of people think that traditions are dead and none of this is happening now. The voices and concerns of native people have not yet reached a large audience, but the exhibition will provide this forum. People must realize that there are voices out there saying things that are worth listening to, and that our native values still exist.

Doug Coffin with snake installation, Snaketown, Gila River, Arizona

# Douglas Coffin

## Exhibitions

✪ *Many Moons*, Klah Gallery, Wheelwright Museum of the American Indian, Santa Fe, New Mexico, 1994

✪ Solo exhibition, Elaine Horwitch Galleries, Santa Fe, New Mexico, 1988

✪ *Totem*, Bonnier Gallery, New York City, 1984

✪ *Artists of the Southwest*, Grand Palais, Paris, France, 1983

✪ *New Work by a New Generation*, Norman MacKenzie Art Gallery, Regina, Canada, 1982

✪ *One with the Earth*, Institute of American Indian Arts, Santa Fe, New Mexico, 1980

## Collections

✪ Institute of American Indian Arts, Santa Fe

✪ Native American Center for the Living Arts, Niagara Falls, New York

✪ Heard Museum, Phoenix, Arizona

✪ Wheelwright Museum of the American Indian, Santa Fe

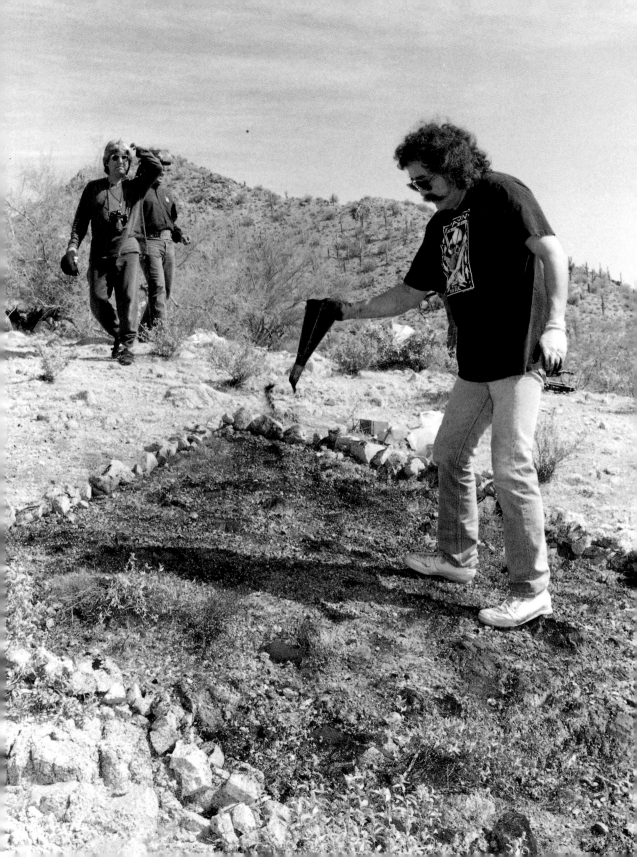

# Allen DeLeary

Allen DeLeary (Ojibway) is a musician, poet, and performance artist. From a young age, he and his siblings were taught an appreciation of their native heritage by their parents—both Ojibway from southwestern Ontario. DeLeary's father was an ironworker, and he grew up with his older brother and two younger sisters in Detroit. DeLeary describes his family as representing "the classic urban Indian scenario."

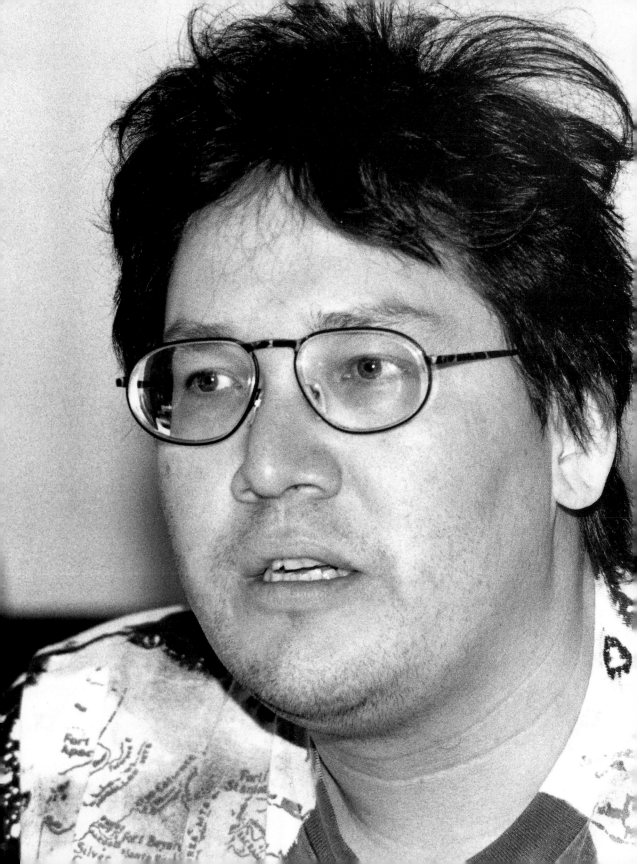

Growing up as a First Nations person in the city had many advantages and disadvantages. The basic First Nations concept of harmony with nature and environment was seriously skewed, simply because we were constantly surrounded by the thriving industrial complex of "Motown." Yet my parents never let us kids forget what our histories were and where our families came from. I was blessed with having known both sets of my grandparents as well as several of my great-grandparents. Further, I often spent summers on the reserve in the company of my grandparents, aunties, and uncles.

My work centers on music, poetry, and performance art. My relationship to these art forms began to develop while I was a management consultant for the Canadian Department of Indian Affairs. During my time as a public servant, I was caught in a web of contradictions. There I was, faithful Indian scout working for the system responsible for caging my people, while attempting to justify that I was perhaps doing the right thing. It was during this time that I began writing about the strange juxtaposition of my job lot in relation to the circumstances of First Nations people across the Americas.

Around 1984, I began listening to reggae music. Especially influential were the dub poets Linton Kwesi Johnson and Mutabaruka. Their in-your-face, no-apologies style of poetry, chanted over the rhythmic pulse of reggae, was enlightening. During this time, a friend of mine befriended a number of musicians from Ottawa's Caribbean community. At first, I listened. As time passed, I was invited to begin chanting my own consciousness poetry over the driving heartbeat of the reggae "riddims."

Nine years have gone by, and I have continued as a musical performer. I am currently fronting the multicultural band 7th Fire—a seven-piece group consisting of four First Nations men, two Latinos,

and, as we are equal opportunity employers, our token "settler citizen."

During the creative process for *This Path We Travel*, our visits to the four sites have had a profound impact upon my life. Each visit has magnified my sensitivity toward the earth as a living, breathing reality. The beauty of the earth is incredible: there is no other force as wondrous as our world. The ability to examine, to work on and with the earth as a performing artist has been enlightening. I want my children to experience the creation process that the earth is constantly undergoing. The experience of performing on Mauna Loa was unforgettable. Synchronicity was achieved between earth and human.

Allen DeLeary,
performance,
Hawai'i

The creative process that has characterized *This Path We Travel* itself has been a dynamic one. It is amazing to have the opportunity to work with indigenous people from all over the Americas. Like any tribal unit attempting to get along for the collective good, the road was often fraught with the difficulties of ego and unclear direction. The spirit of giving, however, was always bountiful. Each person in the group was always willing to lend a hand. Our tribal unit was blessed with the knowledge of our elders, particularly in the case of Josephine Wapp, the tribal *kokum* (grandmother), whose inspiration and strength of character demonstrated the long line of tradition and pride of our ancestors—past, present, and future.

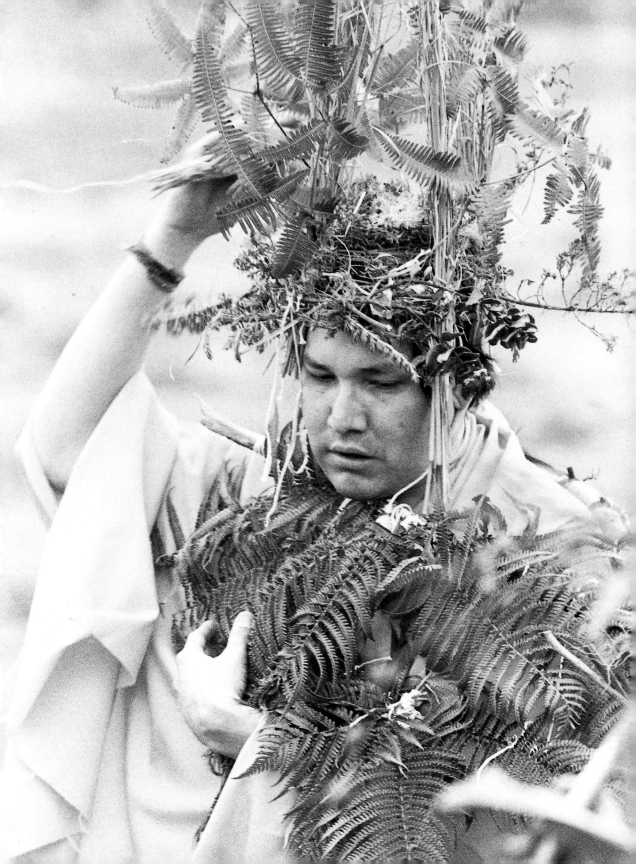

Grab the future by the face. It is incumbent upon each and every individual to defend the planet "by any means necessary," to borrow the words of Malcolm X. Children are the future of this old planet; if we do not give them a fighting chance for the future, then let's end it now. Art is one of the least threatening avenues for espousing social commentary. Further, art has a long history of being a vehicle for social expression. It is the job of each artist to get in touch with this responsibility.

Allen DeLeary,
performance,
Banff,
Alberta, Canada

# Allen DeLeary

**Performances**

⚙ *Nanabush: The Trickster Bottoms Out*, Gallerie SAW Video, Grunt Gallery, 1992

⚙ *The Law of 7 Fires*, Canadian Museum of Civilization, Ottawa, 1991

⚙ *Image of Oka*, Ottawa; Sharing a Dream Festival, Regina; Vancouver International Writers Festival; and *Arts Court*, Ottawa, Radio Free Canada, 1990–91

**7th Fire Band Performances**

⚙ *Native Beat*, Massey Hall, Toronto, 1994

⚙ *Shared Visions*, National Museum of American History, Washington, D.C., 1993

⚙ World Organization of Music, Art and Dance, Harbourfront, Toronto, 1992

**Recordings**

⚙ *The Cheque Is in the Mail*, music video, 1993

⚙ *The Cheque Is in the Mail,* compact disc and cassette, 1993

⚙ *The Death of John Wayne*, video, 1993

⚙ *Keep the Circle Strong*, anti-drug song composed and performed for the Department of National Health and Welfare, Canada, 1991

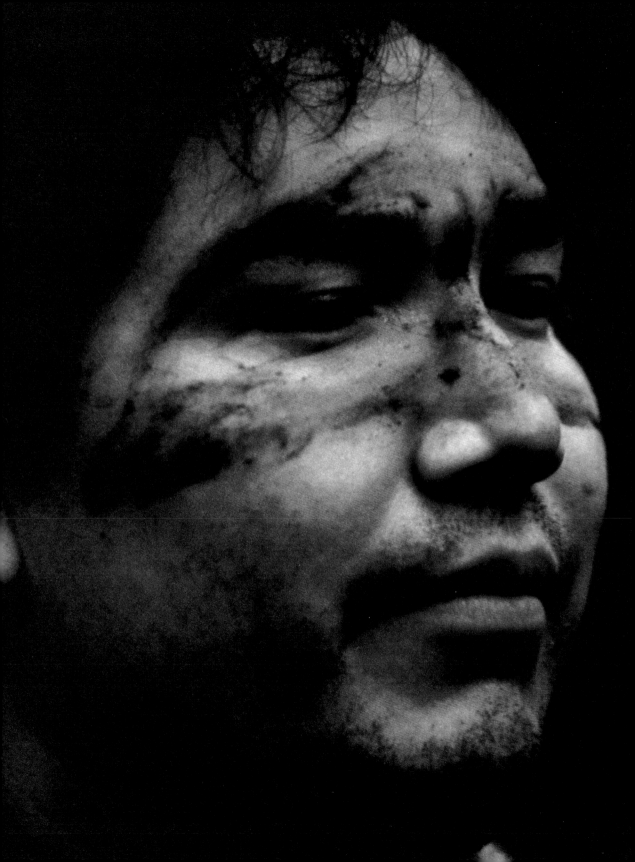

# Pualani Kanaka'ole Kanahele

*Pualani Kanaka'ole Kanahele (Native Hawaiian) notes that her first memories of growing up in Hilo, Hawai'i, revolve around learning the hula'olapa, the traditional Hawaiian dances and chants, from her maternal grandmother. Kanaka'ole Kanahele approaches hula as a cultural reflection of her native ancestry that provides her with a spiritual foundation. She is an instructor at Hawai'i Community College in Hilo, where she teaches Hawaiian language and culture. She regularly gives public lectures for the Hawai'i park system and has lectured and demonstrated hula at venues throughout the country. She is the founder of Ka Lae Makawalu, a hui (group) for Hawaiian female spiritual and political leaders, and co-founder of Hui Malama I Na Kapuna, an organization dedicated to the care of ancestral bones.*

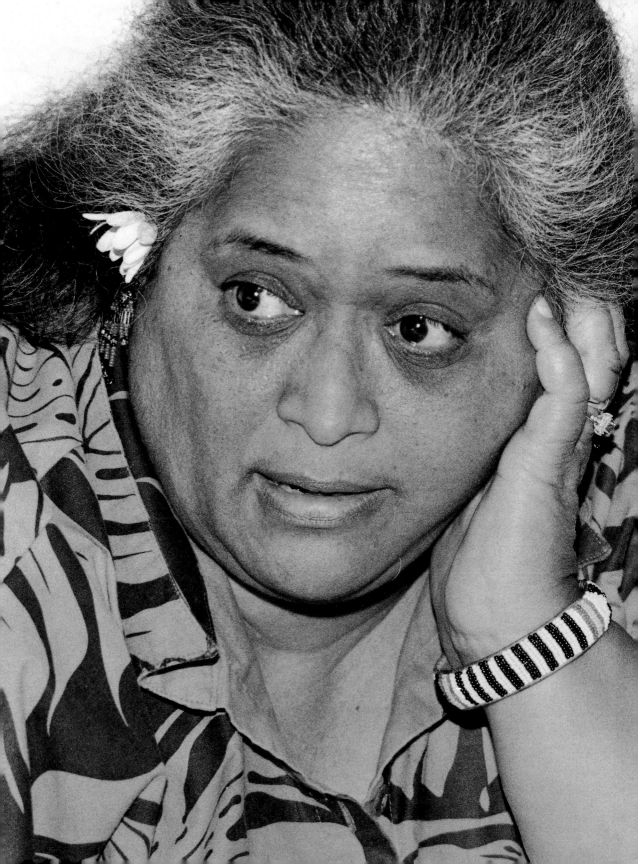

Historic and prehistoric phenomena are the occasions for which chants or songs are created. Hula is the visual display of natural, cultural, or historical occurrences. Hula is not an art form but a cultural reflection upon past happenings. It is a connection to the deities of nature from which the lei adornments of vegetation are made. Therefore, hula has a spiritual foundation.

During the influx of Americans and Europeans to Hawai'i and the introduction of Christian missionaries to these islands, Native Hawaiians suffered tremendous damage to their cultural practices. The first recorded European appeared in the islands in 1778. The first white settlers were Christian missionaries from America who arrived in 1820 and helped establish the sugar industry in the 1800s. The Hawaiian religious system collapsed under the Christian sects. By 1900, Native Hawaiians had lost control of their government and their land tenure system. They now had to compete in a system they did not understand. They had to compete for land and jobs with Caucasians, Chinese, Japanese, Portuguese, and Filipinos who were contracted as workers by the sugar industry. Speaking English, working in the sugar industry, being a Christian, and being an American had become the accepted norm for the leap into the 1900s. The identity of the Native Hawaiian had become worthless and demeaning.

Despite the economic, religious, and political takeover by the Americans, small pockets of intense cultural practices continued undetected. The *hula kapu* was one of the pure forms of spiritual and cultural practice that reaffirmed the continuum of ancestral traditions. Today the *kumu hula* or hula teacher is a liaison of cultural practices. Many kumu hula are respected as the generational component of the living past.

Hula links us to the cyclic evolution of our land, the vegetation that grows on the land, our chiefs and their offspring, the movements of the ocean tides and their association with the moon phases and land vegetation. Hula maintains an awareness of our beginnings and existence in the generational process. Hula is spiritual. It is a very personal expression with a universal quality and an earthly revelation of the past. These dualistic attributes allow for freedom of choreography and interpretation of the chants today. Hula kapu, however, is a genuine presentation of original choreography inspired by the deities.

Another aspect of the hula is the *oli*, or chant. The chant is the entity that gives life to the visual imagery known as hula. The chants are poetic compositions that allow a stylistic interpretation by the composer. The life force of these vocal expressions inspires and captures the spirit and imagery of the words, which in turn inspires the movement of the body, and at this point the hula is born. Thus the *mele*, or song, becomes a chant when sung in a traditional manner. In hula, the body and soul of the dancer are one with the event the dance portrays, whether it is a volcanic eruption, a chief at war, the birth of a child, the wind, or the growth of a forest. The hula is a rebirth of events over and over again.

For me, the hula is the foundation from which I travel upon the path of life. I have deviated from this path to enjoy other aspects of my childhood, to go to college, to learn to fly an airplane, to become a teacher, to become a wife, mother, and grandmother. However, hula has always sustained my confidence in being Hawaiian and pursuing my future by depending upon the richness of my ancestral memories.

I appreciate the stubbornness by which my ancestors kept their identities and philosophy. They survived by a code of ethics and were observers and practitioners of the natural order of things. It was *pono* or good for that era and is pono for this present existence.

Hula is sometimes recognized today as an art form, but more important for some of us who have inherited this tradition, hula is our ancestral past revisited. It is our generational link and a proof of our cultural survival. Hula is Hawaiian, and when we perform the hula and chants—at that moment—we are purely and totally in spirit and in thought Hawaiian. Therefore it is a highly valued vehicle that transforms our world. *E ola mau ka naʻau Hawaiʻi i ka hula* (the Hawaiian spirit will live through hula).

The site visit to the west brought the artists of *This Path We Travel* to Hawaiʻi, my home. I was thrilled to share my island home with continental people. When we went to Arizona, it rained so much that the Gila River area was in flood stage. Because it rains a lot in Hilo, however, I am familiar with the rain, so I thoroughly enjoyed my Arizona encounter. The desert has a quiet reverence, a feeling of antiquity, a cathedral-like ambiance. I was struck with how insignificant we are compared to the vastness of the land. In Hawaiʻi, there is an end to land, a beginning to the ocean and the overwhelming sky dome. In Arizona, the land and sky were ever-present.

The natives of Arizona do not have ocean deities as we do in Hawaiʻi, but they do have migration stories which include the ocean, now long gone except in their stories. At some point during their prehistoric existence, these people were divided according to their environment. One group was known as the river people, taking advantage of

river products such as water for irrigation and mud for pottery. The other group was shaped by and lived in harmony with the many features of the desert. The snake was their brother, and the cactus was the material from which their homes were made, as well as one of their food sources.

Working with mud at the river's edge was a new experience for me. There were thousands of scattered pottery shards as evidence of the old culture at Snaketown. We wandered off and played a hand game upon the old game mounds and felt the soft breeze of winter on our backs. For centuries the breezes have frequented this old village. The warning sound of coyote reminded us we were strangers to the area. We gave thanks to the elements and ancestors of the old village by creating art pieces, songs, dances, and prayers. The importance of our visit is that this old village is now part of our lives. In our creations for *This Path We Travel*, our subconscious connection to this place will influence what we produce. In this way, the old village and the desert will live again.

New York as the easternmost direction was a wake-up call to reality. Natives living in a city also live in harmony with that environment. Visual reminders of life outside the city are necessary if one wishes to maintain his or her cultural identity there; native people living in New York can become "citified." Just as each location we visited influenced the lifestyle found there, the hustle and bustle of the city is the dominant factor in New York. It too will have some influence on each of us during the creation of the exhibition.

I am hopeful that *This Path We Travel* will reawaken the memories that we have experienced in our visits to the different sites, regarding the

sacredness of land, space, sky, and nature's course of action. We are all players in this world of ours. But if we think we are better or know more than other beings on this earth, there is a danger that we might become destructive to those things that give us life. This project is a celebration of those life-giving elemental entities and a re-examination of our pathway of life that includes both the sacred and the profane.

We live simultaneously in the world of our forefathers and in the world as it exists today. If we are successful, it is because we have been able to adapt to both worlds. We cannot deny our ancestral roots and the practices with which we were raised. I have a responsibility to teach my children and grandchildren about their inheritance as Native Hawaiians, and I also have a responsibility to teach my children how to be successful in other aspects of today's world. Higher education is as important as cultural education. Having Hawaiian children and perpetuating the race is as important as fighting in a war to defend your country. Saving a native forest is as important as accepting its destruction by a flood or lava flow. Preventing the destruction of a native burial site for the sake of a hotel is as important as the development of hotels for the economic well-being of people.

Some of these seemingly conflicting values are difficult to maintain for any length of time. There comes a time to balance one's sense of being. Watching the sun rise or set gives me a sense of balance. Observing the forces of the ocean against the shoreline or of volcanic eruption gives me a sense of a larger purpose for life. I am fortunate to see the multiple colors on the mountains or the columns of rain on the ocean. These experiences bring balance to me and help me realize I am part of the natural flow and order of life.

We as artists and practitioners will try, despite limitations, to project within the exhibition the pathway of life that includes both the sacred and the profane. Both are part of our life, and if we recognize the negative and positive of each, we will have stepped out of the profane and into the sacred.

Pualani Kanaka'ole Kanahele,
Jane Lind,
Hulleah Tsinhnahjinnie,
performance, Snaketown,
Gila River, Arizona

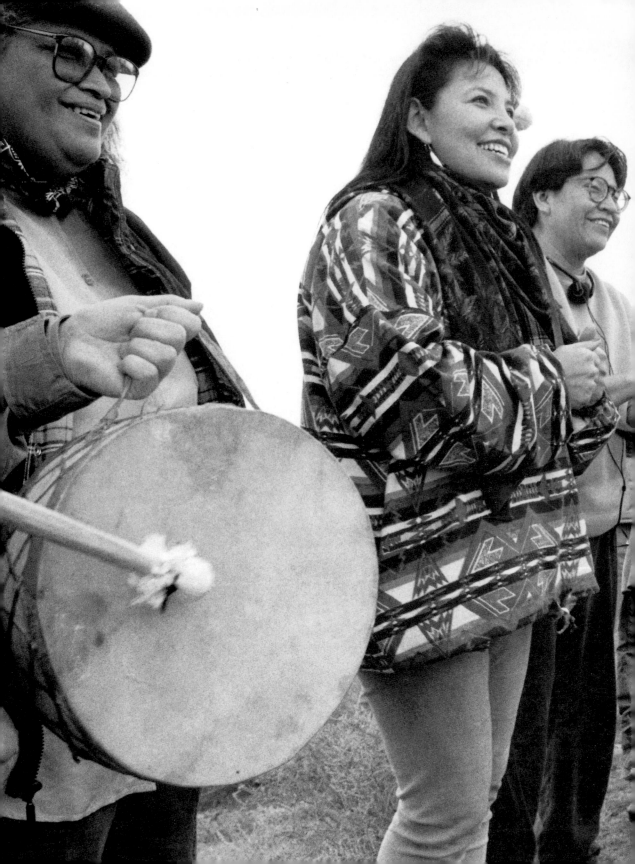

# Pualani Kanaka'ole Kanahele

**Performances and Lectures**

✪ "Proper Offerings to Pele According to Chants and Oral Traditions," *After Dark in the Park*, Volcanoes National Park, Hawai'i, 1992

✪ "Hawaiian Values," Kaumakapili and Kane'ohe, Hawai'i, 1992

✪ "Pele and Hi'iaka," Volcano Art Center, Hawai'i, 1988–89

✪ Los Angeles Culture Festival, performance and forum, 1987–88

✪ "The Education of Hawaiians," Volcano Art Center, 1987

✪ Lecture and demonstration at Laguna, Zuni, Zia, Taos, Santo Domingo, Tesuque, Isleta, Santa Clara, and San Juan Pueblos; Ramah and Pine Hill Schools; Santa Fe Museum; and Institute of American Indian Arts, New Mexico, 1987

**Publications**

✪ *Pele, the Fire Goddess,* Honolulu: Bishop Museum Press, 1991

✪ *Maui Chants,* Honolulu: Alu Like, 1988

✪ *Ka Honua Ola,* State Foundation of Culture and the Arts/University of Hawai'i, Manoa, Hawaiian Studies, 1992

**Videos**

✪ *Who Will Save the Bones?* and *Pele's Appeal,* Na Maka o Ka 'Aina, 1988 and 1990

Art created on site,
Snaketown,
Gila River, Arizona

Artists rehearsing
for performance,
Phoenix, Arizona

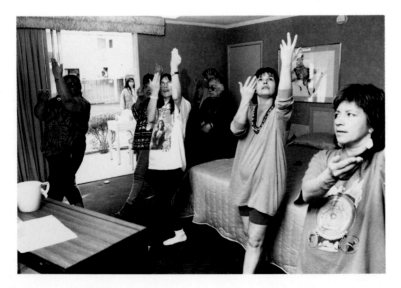

# Margo Kane

*Margo Kane (Cree–Saulteaux–Blackfoot) is a multidisciplinary artist and a leading figure in native performing arts. Over the past twenty years, she has been recognized as a storyteller, dancer, singer, animator, video and installation artist, director, producer, writer, and teacher. In addition to her extensive career in film, radio, and television, she has performed new work in theaters, galleries, and communities nationwide. Her desire to create work that has meaning for her people is the catalyst for her exten-sive travels into both rural and urban native communities across Canada, and fuels her commitment to performance that is not only socially relevant, but empowering.*

It has been said by some native historians that artists are like "living water" to their communities, but their traditional obligations have been forgotten with the advent of colonization and all the problems inherent in that Western belief system. I have long wanted to reclaim and identify with the role of the artist as I imagine it must have been in our traditional communities—to be an artist whose contribution brings honor and inspiration to her community. At one point in my life, I wanted to return to my work within native communities, but as an Indian child adopted into a non-native family, I felt I had no community to return to. And that desire was at odds with my need to have an urban contemporary life, one in which I would have the resources to make outreach possible. Ultimately, my hope has been to live the balanced, interconnected life espoused by native tradition.

Margo Kane,
performance,
Banff,
Alberta, Canada

Extensive travel into rural and urban native communities with the National Native Rolemodel Program over many years has brought me into the heart of "Indian Country" throughout Canada. Participating in cultural camps, leading theater workshops and youth conferences, facilitating talking circles, and creating videos and performances with the people have all contributed to my sense of belonging to the greater native community.

In the native communities I visit, Western styles of singing, dancing, and acting are often intriguing to the people, especially the youth. But what do these Western art forms have to do with anything they know? Their own rich culture is being obliterated by pop culture and the values of a superficial, commercial society, as seen in television, video games, and movies.

Some of my earliest creations and collaborations examine issues of belonging, identity, survival, repatriation, and memory. *Reflections in the Medicine Wheel*, for example, addresses wisdom that passes on or is waiting to be shared, while society chases after yet another illusion. But much of the content of productions I've worked on in the past has not been compelling for me. It has little to do with the perspectives of native people. It has little to do with me.

Working in the native communities has been a catalyst for change and an inspirational possibility for me. Some of the community teachers I worked with nurtured me and inspired me to write *Moonlodge*, my one-woman show. It was also these teachers who encouraged and supported me in the search for my family. That search has been a long and dusty road with several dead ends, before finally reaching "home." The reunion was not an easy negotiation, but through it all, I continued to create.

Some of my solo work addresses issues of a displaced identity, revealing layers of self-identity that were the result of education and socialization I experienced growing up in the 1950s in a northern Canadian prairie town. *We've Always Been Here* and *Childhood Burial* peel away the layers of protection that I needed as an adopted Indian child living in a rural land where Indians were considered "too dirty, too lazy, or too drunk" to farm their land. However, much of my work is full of irony and laughter. *O Elijah*, *Princess Minnehaha at the Tikki Tikki Lounge*, and *Moonlodge* are full of humor. Clowning is part of my performance identity, and a key to my survival.

With limited experience in my community and limited access to resources, the balance between pursuing my art career and community development

has been difficult to maintain. Leaving the communities and the land to organize and create in the city is a decision I have struggled with time and time again. I have encountered difficulty in having my work funded and seen, not just in urban centers, but in the communities I cannot forget. I continue to initiate different projects that involve members of my community in productions, workshops, and performances.

Working on the collaborative *This Path We Travel* project with the National Museum of the American Indian offered me the opportunity to share thoughts and beliefs with my fellow artists, and exposed me to the perspectives of other like-minded individuals who experience similar feelings of personal and community responsibility. They understand the conflict and constant negotiation involved in shifting from the personal to the community—the difficulties of differences in language and context. They understand the struggle with issues of identity within their communities.

Throughout our meetings we listened, we disagreed, we collaborated, and we created together. At our Arizona gathering, melodies arose from drums, flutes, gourds, and voices from a high mountaintop at sunset. We sang and drummed as other artists worked. We shared stories and ideas throughout all our journeys and worked together to transform land into objects and sculpture. We honored the completion of these pieces with songs, dances, and prayers. All of our works were created

from the land and left to honor the grandfathers and grandmothers of each place.

Our hosts always generously shared their personal and tribal histories, songs, and ceremonies. They showed us their lands and feasted with us. They honored us, and we in turn honored them; it was reaffirming. As artists, we were valued and appreciated by our own.

To truly face the road ahead with perseverance, optimism, and humor, I have to find a way to integrate all parts of myself and maintain relationships with those things that sustain me and nurture my existence—the land, the people, myself. It is not an easy task. Working with the other artists on the project, I saw many of us traveling this road together. I know how valuable it is to have knowledge of your own history—who you are and where you come from. Our stories need to be kept alive and shared. The next generation needs to learn from today's artists, who are also part of the story. We need to acknowledge one another for the valuable part we play.

It is a challenge to face our future with resolve and optimism in spite of the negative forces around us. Native people will deal with issues of relocation, identity, status and lack of status, on-reserve and off-reserve, cultural appropriation, contemporary versus traditional art, sovereignty, self-determination, and self-government. Survival is a complex negotiation.

# Margo Kane

## Performances

⊛ *Memories Springing/Waters Singing*, performance and video installation, Walter Phillips Gallery, Banff Centre for the Arts, Canada, 1992

⊛ *I Walk, I Remember*, performance and installation, Grunt Gallery, Vancouver, Canada, 1992

⊛ *Princess Minnehaha at the Tikki Tikki Lounge*, Women in View Festival, Vancouver, 1992

## Publications

⊛ *Written in Stone*, Green Thumb Theatre for Young Audiences, Vancouver, 1992

⊛ *Moonlodge*, Women in View Festival, one-woman show, Vancouver, 1990

⊛ *Reflections in the Medicine Wheel*, Folklife, World Expo '86, Vancouver, 1986

## Acting/Directing

⊛ *Moonlodge*, one-woman show, The Grand Theatre, London, Ontario; Woodland Cultural Centre, Six Nations Reserve; Helen Gardiner Playhouse, University College of Toronto; ongoing tour of U.S. and Canada, 1994

⊛ *The River Home*, work-in-progress, 1994

⊛ Fran (Principal), in *Good Things 2*, NFB Film, with Liz Skully, 1994

⊛ Imogene (Principal), in *Powwow Highway*, Handmade Films, with Jonathan Wacks, 1987

Margo Kane,
performance,
Snaketown,
Gila River, Arizona

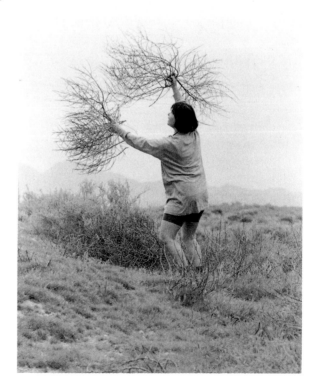

# Frank LaPena

Frank LaPena (Wintu–Nomtipom) was born in San Francisco in 1937 and attended federal Indian boarding school in Stewart, Nevada, near Carson City. His interest in the arts began in high school and continued through college, where he discovered he excelled in his art classes. His paintings and sculpture reflect a deep interest and appreciation of his native heritage, and he shares this with his students as professor of art and director of Native American studies at California State University, Sacramento. A traditional dancer, singer, and practitioner of Wintu culture, LaPena has exhibited his artwork in venues throughout the United States for the past thirty years. He is also a member of the performance group, Maidu Dancers and Traditionalists.

My fascination with colors and the making of pictures is something I've been aware of all my life. My first notion of what art could do was when my mother colored a picture of a Marine in one of my coloring books. It was during the Second World War, and the picture took on a realism that was total for me. I remember tearing out the page and carrying it around for a long time. This happened before I started going to the federal Indian boarding school in Stewart, Nevada.

I was born in San Francisco; on my father's side I am Asian and first-generation American. On my mother's side our beginnings are traced back to the time of emergence from this earth. My father came here as a young boy of eleven and was killed when he was twenty-nine. I was five at the time, and it affected me deeply. Circumstances thus emphasized my involvement in my Native American culture. When my father was killed, an owl came and told us of his death, and a special burning of feathers and mourning had to be done in order to free his spirit from the house. My painting *Burning Feathers* is about this event.

My tribe, the Wintu–Nomtipom, are a mountain river people of northern California. My mother's grandmother was from the upper Sacramento River Canyon in the Cedar district around Slate Creek. Grandma Rose married Garfield Towendolly from the Trinity Center area. His family held "head rights" and were responsible for the maintenance and preservation of tradition.

Grandma Rose was special. I lived with her some of the time, and I remember the clear water of Castle Creek and the flume that brought the water to the house. The Castle Crags towered to the west of us and the woods were close by. To the north was Shasta Mountain, and in the winter it made its own weather because it was high and massive. The rivers were clean and full of native fish. One time I caught a water snake and tried to scare Granny. I remember the smell and the color of the apples she used to keep on the porch. When I was growing up in the Indian schools, and later when I heard that "Indians" were bad, I knew instinctively that people who were saying this did not know what they were talking about. They did not know Indian people. Even at a young age I could understand this.

The first time we went to the Indian school it was snowing, and it took a long time to get there, but I was too young to be accepted, so we had to go back home. When I finally started school, one thing that separated me from the others was that I could do art—a lot of the other kids could do art too, but I had a preoccupation with it and could do it for a long time. Not only did I enjoy doing it, it was like magic in a way, and perhaps it kept me in touch with the memory of my mother.

In the severe winters of the early 1940s, the devastation to the Southwest tribes, especially the Navajo, forced the Bureau of Indian Affairs to provide more boarding school room for them. As a result, we were sent to the federal Indian boarding school at Chemawa, Oregon, in 1948. Eventually, my sister Barbara, brother Ben, and I were put into a foster home in northern California. My first attendance in a public school was eighth grade in Grenada Elementary School in Siskiyou County.

Because art was always a part of my life, I never gave much thought to it—I just did it. I took mechanical drawing classes in Yreka High School, but not art classes. It wasn't until college at Chico State that I decided to take one art class, which was an elective. I ended up doing poorly in most of my other classes because I spent all my time doing art, and promptly switched my major from the sciences to art.

When I went to Oregon to work as an adult on my own for the first time, I came back because of homesickness; I needed to be able to see high mountains and watch the clouds and sky change. I learned something about myself then. I still hadn't finished college—it took me nine years to get my degree—but I never gave up trying to finish. I was determined to make good for my family, because no one from either side of the family had ever graduated from college.

I consider the process of art to be the most important element in the doing of art. In creating art, people and events are remembered. Being able to go back and forth in time for inspiration and to arrive at forms and colors can be quite exciting. Ideas and shapes are never the same; one can never get bored. Sometimes I work from concrete ideas such as a specific theme, but as I work there is a spontaneity, and images emerge in the paint on the canvas. When I am doing my art all other things drop away and I follow the magic of discovery; the journey is unpredictable and never-ending.

Having exhibited my artwork for more than thirty years now, there is a lot of art I still want to do. At this time in my life I can appreciate hard work. And I realize that it is better to seek quality and excellence in one's work because a full life has both good and bad, and before one knows it, all the unfulfilled things are lost along the way. One's health and abilities do not last forever.

*This Path We Travel* is a worthwhile project and long overdue. Obviously, it is a watershed event for the Heye collection and a public reminder of the greater National Museum of the American Indian to be built on the Mall in Washington, D.C., at the turn of the century. It has been fascinating to meet all of the excellent artists and to hear about their respective creative fields. This admiration does not diminish in my mind when some of them have had to drop out of this project, because others have struggled to hang on. I sense a camaraderie and concern with the issues we have articulated, and perhaps a joy of discovery with each other and with the sites we have visited. Part of this goodwill has been with the land, with each other, the art produced through group and individual action, and by the meetings with elders and other caring individuals who have enlightened us with their knowledge.

Those people who say, "What are these artists doing?" or "Can they pull it off?" need to realize that our experiences help define our artwork. When we went to Morley, Alberta, Canada, I was pleased to be where the elders had kept their tribal consciousness of the world alive by sharing their beliefs and concerns in council. I had never made it to the previous councils, so I was happy to hear the tradition would be started again.

I have lived close to water for most of my life and know its power. In Morley, I sang to and with the river because it was alive and so was I—and the land was sacred and alive. Singing to the river awakened a sound, a sound of moving together and joining with the wind. In this place and at this time—immediate and transitory—a process developed among the song, the river, and the land. One could crawl along the shore and discover the universe in stones, in the color and textures of river materials, or one could wander through grottos of rock canyons and create that primal sound of flute and voice.

Some of the artists and I found the universe of the four directions in a white schist cross on black granite, and placed our hands on the stone with earth's pigments to bring the symbol alive.

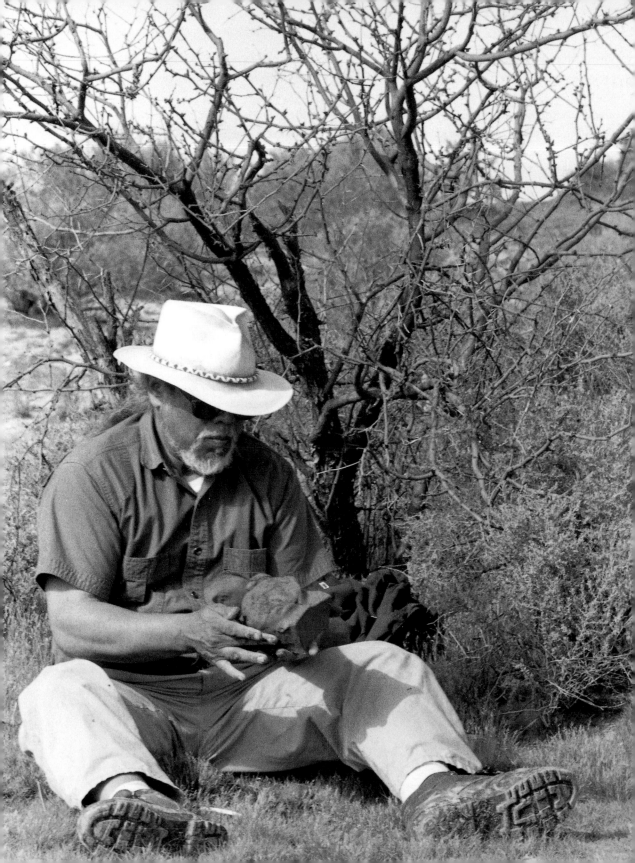

We laughed and prayed, and when we finished, a light sprinkle of rain blessed our efforts with water. We were silent then, and when I talked about this later, I found my eyes brimming with tears. We filled those canyons with song, and the weekend hikers and mountain climbers were in their element just as we were.

I could not make it to Hawai'i, but as I viewed the video of the trip, I was impressed by the power of the ocean. We landlubbers tend to forget how limited our movements are, regulated by the land. Because the earth is three-quarters water, most of the settlement of the earth has been by people traveling by water. Water, fire, vents of steam and lava, and the magic of emerging, lost beings behind curtains, mists, and the song of the chanter; these were magic enough for me. I could see the joy in the native people and how that naturalness seemed to free the spirit of the members of our group. The women never looked more beautiful to me.

Frank LaPena,
Snaketown,
Gila River, Arizona

On the banks of the Gila River floodplain, I was enchanted by the birds singing in the morning. They were everywhere. This is when song is most relevant—when one's own efforts fall short but one cannot escape the trying. Later, we had to cross the floodplain to reach the fields of birdsong, and our own footprints went down by

those of the coyote, wildcat, and birds. We stayed and sculpted the clay into animals, gods, little-known beings, and little people of the imagination. I liked this time of isolation from the others, walking in mud and singing and creating—the time flew. The next day we came back to see our creations drying and flaking apart under the hot sun, returning to the earth from where they came. The Gila River Tribal Council members had never had a group come to them like ours—where nothing was taken—and all works were left on the land.

We have met so many times in New York City it is hard to relate to it as the site representing the eastern direction. Meeting with the Indian community there seemed circumstantial and not as open as at the other sites. New York City has been like a long lost uncle or distant cousin to me; I know I have a relationship with it, but I don't really know what kind of relationship it is. I know the city is a cultural mecca, but I haven't been able to see the galleries, or participate in the life of the city as I have had the opportunity to do at the other locations.

*This Path We Travel* is difficult to define because it is a conceptual exhibition. Some of the artworks are social commentary, others give form to tribal concepts—such as the use of symbols—and some share the artists' concerns about existence as human beings. Ultimately, the exhibition is a celebration of life, an affirmation for art and Native Americans, and a continuous, evolving story of the spirit of the earth and all living things.

# Frank LaPena

## Exhibitions

○ *The Spirit of Native America*, American Indian Contemporary Arts, San Francisco and Latin America Tour, 1993–96

○ *Shared Experiences/Personal Interpretations: Seven Native American Artists*, University Art Gallery, Sonoma State University, California, 1993

○ *Sanctuaries: Recovering the Holy in Contemporary Art*, The Museum of Contemporary Religious Art, St. Louis University, 1993

○ *Visions and Voices*, University of California Museum of Art, Science and Culture, Blackhawk, Danville, California, 1993

○ *Encounters*, Lincoln Plaza Gallery, Sacramento, California, and tour to Vancouver, Canada, and Mexico City, 1992–94

○ *Ancestral Memories*, Falkirk Cultural Center, San Rafael, California, 1992

○ *Native American Art*, Galerie Calumet, Heidelberg, Germany, and the German-American Institute, Stuttgart, 1992

○ *Shared Visions*, Heard Museum, Phoenix, national and international traveling exhibition, 1991–95

○ *Our Land, Ourselves*, University Art Gallery, State University of New York, Albany, and New England and national tour, 1991–95

○ *Sacred Spaces, Spirit Places: The World View Imagery of Five North-Central California Indian Artists*, Memorial Union Gallery, University of California, Davis, 1991

Handprints
installation,
Alberta, Canada

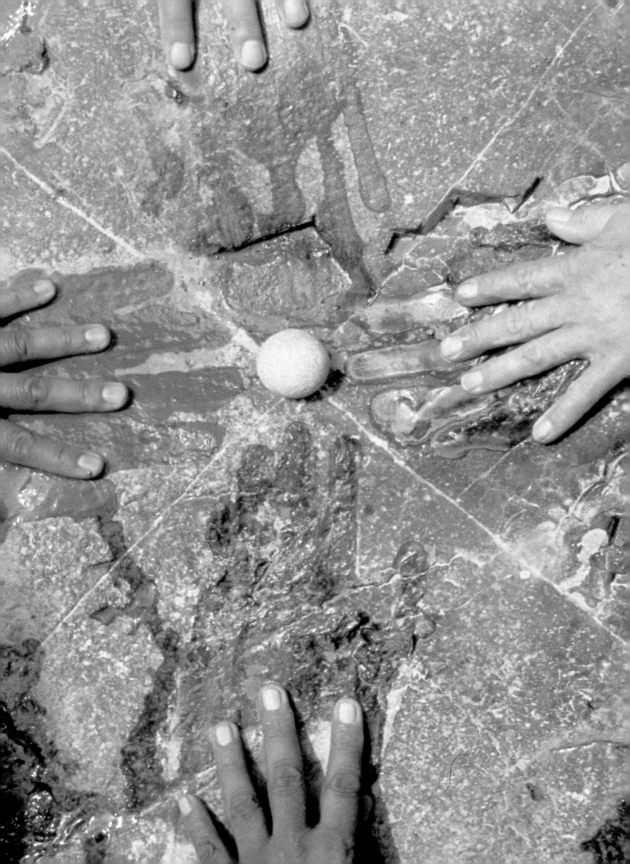

# Jane Lind

*Jane Lind (Aleut) was born on Humpback Bay, near the village of Perryville on the Alaska Peninsula, where her family hunted and fished and gathered food off the land. As a young child, she lived and learned the traditional Aleut ways, and her earliest recollections of acting were of participating in Aleut "masking" or "covering-the-face" ceremonies. She began formal theatrical training in New York City, where she studied at the New York University of the Arts and worked at the Native American Theater. She also studied at the Institute of American Indian Arts in Santa Fe, New Mexico. She is an actor, director, and choreographer who has participated in productions throughout the United States and Europe. Lind is currently the resident stage director and acting teacher for the Magic Circle Opera Repertory Ensemble in New York.*

My earliest recollections in acting began in my childhood years in Chignik, Alaska, when I participated in traditional Aleut ceremonies. Aleut "masking" or "covering-the-face" ceremonies take place during the Russian Orthodox Christmas holidays and incorporate Russian music and the story of the Wise Men into our native traditions and stories. At night, people of our community don masks and disguise themselves in elaborate costumes, sometimes carrying whistles in their mouths, so as not to talk and be recognized. We go from house to house, dancing and making merry, while spectators laugh at our antics and try to guess our identity. At midnight, our masks are removed. We believe that it is possible for the spirit of the being that the mask and costume portray to enter our bodies. Therefore, at the conclusion of these ceremonies, when we remove our masks, we wash our faces to dismiss any spirits or their characterizations. This ritual of washing the face, remembered from my childhood, is a tradition I continue to observe strictly in my own acting career.

My heritage, both Aleut and Russian, is a guiding force behind my work as an actress, director, choreographer, and teacher. I grew up in the Aleutian Peninsula in Alaska, in a culture that always had theater, although I didn't recognize it as theater at the time. My surroundings—volcanoes, windstorms, and the sea, along with molten rock and ash spilling from Mt. Veniaminof near my village of Perryville—certainly stirred something in me at a very early age. Being raised among the pageantry of Russian Orthodox traditions was also influential. When I was growing up, I sang, in Russian, in the church choir. I have a little Russian blood in me of which I'm very proud, and thanks to the words of my grandmother, "You identify with everything in you," I am reminded that both Aleut and Russian cultures are very much a part of my life.

We are a people of dance and storytelling. We came from that place of ceremony, from that place of ritual, which to me is what performance is all about. Nothing in the world gives me the same feeling as acting, except when I go home and see the animals, talk with the elders, and watch the children laugh.

My first on-site experience with the *This Path We Travel* collaborative effort was in Hawai'i. Sharing our stories with our hosts on the Big Island was wonderful and made me feel at home as the land welcomed us. Perhaps the reason for my personal feeling of connection with Hawai'i was that I grew up in an environment alive with active volcanoes, and the sea evoked memories for me that were especially cleansing to my spirit.

Feeling what the Native Hawaiians know and shared with us about the two sides of the island, female and male, made the visit particularly pertinent to the *This Path We Travel* project, in which we plan to emphasize the roles of female and male. This natural division of the land raised some conflicts in the group as to how we would portray these two forces in the exhibition. Grandma used to say if there were no conflicts, we would not be alive. For me, I guess it's just how we embrace them. By the time we left, I felt that we had not had quite enough time together. It seemed that just when we were beginning to talk and create it was time to leave.

By the time the group came to Arizona, our site representing the southern cardinal direction, I felt the group as a whole was stronger. We became more cohesive in our work with one another and with the land. Some of us created individual sculptures with clay from the Gila River in Snaketown. I found this process meaningful and humbling, because the land gave us permission.

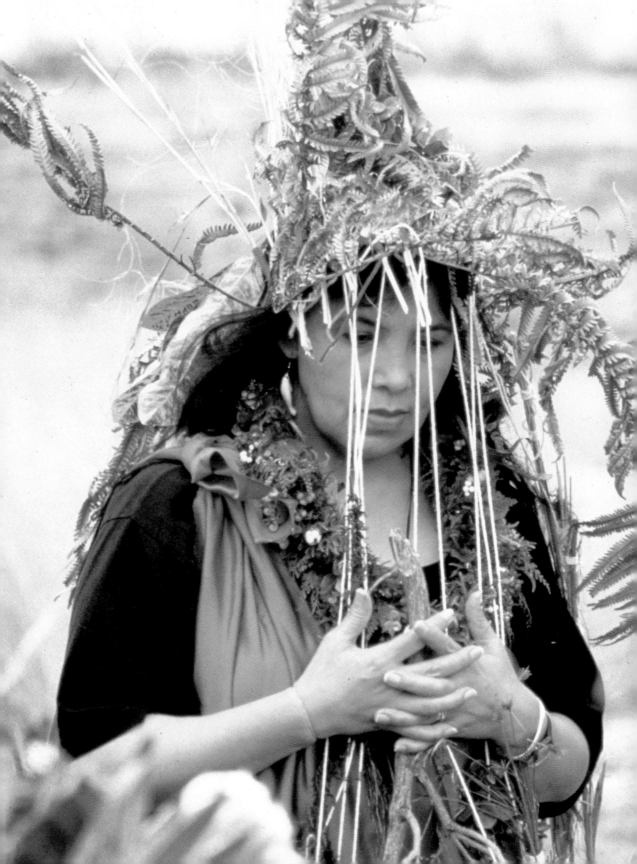

The beauty of our indigenous people touched and cradled my heart even with all the modern-day problems we saw that indigenous people still face, especially stereotyping, by both natives and non-natives. I will continue to address these issues with my work in theater and film. I hope one day to return to Alaska to develop native theater, to encourage more Alaskan natives to use theater as a teaching tool, and to cultivate native spirituality and culture, which have been deteriorating because of Western religion and modern society.

# Jane Lind

## Acting

❂ Co-star opposite Chuck Conners in *Salmonberries*, 1991

❂ Kirizuzu in John Vaccaro's *Nightclub*, 1982

❂ Clytemnestra and Hecuba in André Serban's *Greek Trilogy*, 1978–81

❂ The Bird in Peter Brook's *Conference of the Birds*, 1975

❂ Various roles in Ellen Stewart's *La Mama Theater*, 1972–82

## Directing/Teaching

❂ Director for Magic Circle Opera Repertory Company, 1989–present

❂ Assistant director of Hanay Geiogamah's Native American Dance Theater, 1990

❂ Director for Christopher Sergel's *Black Elk Speaks*, 1989

❂ Actor and teacher with Dana Hart for the Alaska Repertory Theater Playmaking Program, 1984–87

❂ Co-founder, with Renee Patten, Spirit Theater, Bethel, Alaska, 1988; and founding member of Native American Theater Ensemble, 1973

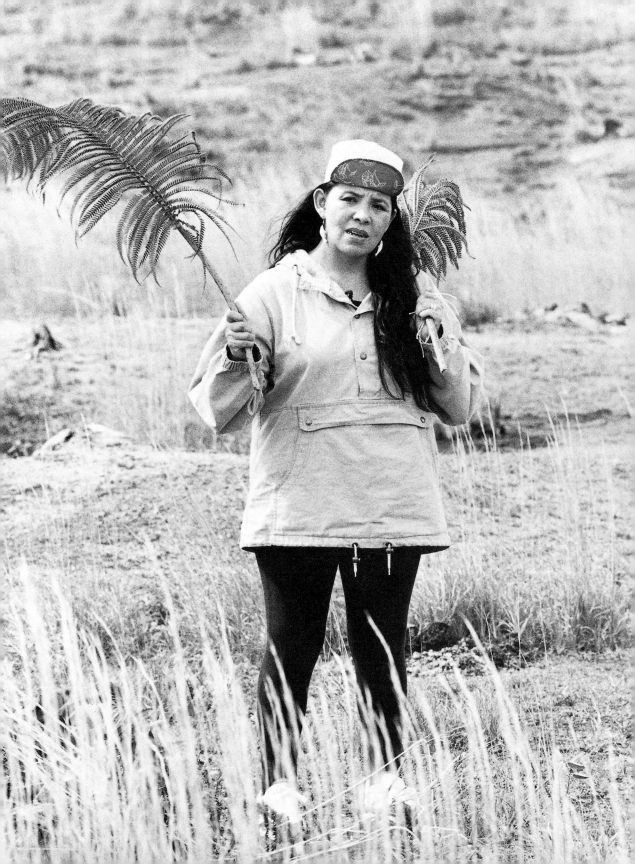

# Harold Littlebird

Harold Littlebird (Santo Domingo–Laguna Pueblo) is a multidisciplinary performance artist. He was born in Albuquerque, New Mexico, and attended high school at the Institute of American Indian Arts in Santa Fe, where he developed an interest in pottery. He later studied as an apprentice to a professional potter. Littlebird is also a poet and contemporary singer-songwriter. Most recently, he has put colored pen and ink to paper, creating a new art form by combining pieces of his poetry with his intricate Mimbres-influenced pottery drawings. He has been an artist-in-residence at many schools throughout the United States, and has performed in such venues as Robert Redford's Sundance Film Institute, the Houston Center for the Performing Arts, and the World Future Society Conference. His book of poetry, On Mountain's Breath, is in its third printing, and he has been published in numerous anthologies and magazines. He has produced two cassettes of his poetry and songs and is currently working on a third.

I was born in Albuquerque, New Mexico, the fourth child of my Laguna Pueblo mother (Andrea Sarracino Bird) and my Santo Domingo Pueblo father (Tony L. Bird). I lived in Paguate, New Mexico, on the Laguna Reservation off and on until I was about five years old. My father then moved our family out to California where he worked for the Southern Pacific Railroad. I returned to New Mexico as a rebellious teenager, living with my oldest brother, Larry, in the northern part of the state; before that, I had lived in California and northern Utah most of my childhood, with just a few summer visits to New Mexico.

*I relive in sleep, long gone-away days*
*Green scattered foothills of piñon & pine*
*Where I ran for awhile, with my brother, Larry*
*And romped away, a young lifetime of mine.*[1]

During the "flower child" explosion and the mass-exodus, back-to-nature movement of the hippie generation, I was greatly influenced as a poet and songwriter by East and West Coast poets such as Allen Ginsberg, Michael McClure, Lawrence Ferlinghetti, Lenore Kandel, and the late Emmett Grogan—

*They came from the West Coast, as from the East*
*Searching for vision, souls needing sleep*
*Poets & beggars, musicians & priests*
*And those out of luck, with missions to keep*[2]

who visited or lived with us in El Rito, from time to time. Musically, I was drawn to the lyrics of Bob Dylan and Van Morrison and began to write songs of my own. Allen Ginsberg's delightful chanting with finger cymbals, and his raspy voice accompanied by harmonium, played a major role in the development of my musical appreciation.

About this same time, I began participating in village ceremonies in various ways. I was curious, and wanted to know more about my ancestry through religious participation. Out of desire, and ultimately responsibility, I began to listen.

*With a forward, thrusted, headlong surge*
*On a twisting, whirling, blink of time*
*Fervored wings began to shape me*
*Hidden shadows of harmonic rhyme.*[3]

While attending high school at the Institute of American Indian Arts in Santa Fe, I became interested in pottery under the creative direction of Ralph Pardington, the contemporary ceramics instructor.

*So instead I ran, the artist*
*Shape, create with fire & clay*
*Fleeting years played as the student*
*Seemed so unreal and far away.*[4]

Under his tutelage, pottery became another medium in which to express my newly awakened involvement in my Pueblo ancestry. I graduated from IAIA in 1969 and continued to participate actively in the ceremonial ways of both my mother's and father's villages.

*A fledgling hawk yearning to soar*
*Initiate to realms of unwritten history*
*Adobe houses, mud-plastered villages*
*Currents of awakened ancestry.*[5]

Through repeated ceremonial participation and involvement over the years, I have begun to be aware of limitless ancestral stories about this abundant Creation, passed on to generations through the ritual guidance of song, practice, and prayer.

*Clacking, spiraled ocean shells*
*Shiny metal bells, jing-jangling*
*Resonant prayer, rhythms pound*
*Deep, like blood, immemorial singing.*[6]

I have been repeatedly told and shown how we human beings are only one of many vital parts within Creation. In our everyday lives, there exists the task of understanding the interconnectedness of all life.

The value within native stories becomes focused and real as I begin to observe in a different way the "writings" within my Pueblo landscape. Geographic sites of ancient rock drawings and petroglyphs, as well as religious shrines and abandoned ruins—the ancestral homes of my forefathers—add meaning and visual definition to the tribal history I am just beginning to sense.

Having little understanding of my native tongue, I use the English language as a tool for conveying my own creative voice, but that creativity has a greater source than just my cultural traditions. It becomes increasingly clear to me as I create pottery, write poetry, compose contemporary songs, and joyfully celebrate daily life that the physical and spiritual landscape of my homeland, the Southwest, helps me develop creativity. For this gift from the Creator, I am truly thankful.

I have been very fortunate to attend all but one of the group meetings for *This Path We Travel*, and each site has had a very strong emotional and spiritual impact on my life. My first experience with this project was in New York City, meeting with a few old schoolmates who have chosen careers in the arts, and sharing our personal histories as contemporaries. I then met new brothers and sisters of the arts with whom I would collaborate in this project. The seed of this project was planted, for me, in the

group sharing of stories about our individual artistic disciplines and how we planned to represent our diverse yet connected ideas in the project we tentatively entitled *Celebrations*.

Having the opportunity to visit NMAI's collection and pay our respects to the ancestors of all our nations was very important to me, because it reminded me of the living spirit of Native American spirituality. The objects and artifacts in the collection that we saw or touched are not just material matter, but represent a way of being that is manifested today. It saddened me to view or touch certain objects, because of the historical record of atrocities that were waged upon our people in order to gather these living documents from our forefathers. Yet, at the same time, it gladdened me to witness firsthand the meaningful harmony that these objects are charged with and impart. They offer courage and hope to each of us in their own powerful and holy way.

We conducted the first working meeting of the project participants in Alberta, Canada, representing the northern cardinal direction. The group was invited to visit the Stoney Reserve in Alberta as guests of the Nakoda people. It was here that our collaboration as artists germinated. After a brief group meeting sharing ideas, we broke into smaller groups to begin the work. The first morning, some of the other artists and I gathered willows in the rain for the building of our "world," or "sphere" (see page xxi).

What particularly stands out for me about the meeting in Alberta was the way everyone volunteered their time and generated their energies to benefit each project as it appeared, and how—miraculously—all of the projects intertwined. I was personally touched by how the ceremony of "the coming of the animals" evolved. Each of us in that

group gathered natural materials to supplement our handmade costumes representing beings of land, sea, sky, and nature. The procession that emerged, through ritual dance and movement, commemorated the life-play that our Mother Earth (represented by the willow sphere) provides for all of her creatures and children.

The third on-site meeting took place in Hawai'i, representing the western cardinal direction. I became aware through the traditional stories of our hosts that the Big Island was metaphorically and physically divided into two parts, male and female. Several of us were fortunate to work on both sides of the island. I was honored to work with the women of our group on the female side of the island in a dance-theater performance that emerged from a creation story of the Aleut Nation. It gave me the opportunity to work with drama, theater, and performance artists, and to share in their expertise. We enacted a mystery play, led by an elder of the island, in a sacred place reserved for dance ritual (facing page). Just being in that sacred space was humbling and gave me the meditative silence to reflect on the events of our visit to the female side of the island. I remember the forces of Creation at work—watching molten red lava flow into the waiting waters of oceanic embrace, or hearing the hiss of steam rise skyward in vaporous clouds, only to settle gently on my bare, browned arms and face. Remembering the experience, I still feel the radiant, rumbling breath of Creation.

In Pololu Valley on the male side of the Big Island, we shared songs and stories in the home of Kindy Sproat, north Kohala's own troubadour and storyteller extraordinaire, and his wife Cheryl. Laughter and song floated magically in the constant wind surrounding their clifftop home that over-looked the turbulent, turquoise waters of the Pacific. Far into the windy night, song and story wove a

spell to those still awake. I will never forget the hospitality afforded our group, and myself, by all of the elders and young people of north Kohala and Hilo. *Mahalo* and *aloha*, island brothers and sisters.

The last working site meeting was held in Phoenix, representing the southern cardinal point. We were invited to visit ancient homes and ancestral ruins of the desert and river people of the Gila River. We also visited Casa Grande Ruins National Monument. Once again, groups of us chose to involve ourselves with numerous projects. One of the days I worked alongside the others, building sculptures with natural riverbed clay. I helped José build an *apacheta*, a Mesoamerican stone cairn used to mark sacred spaces, on the hillside (see page 9). We were all part of a ceremony of prayer, chant, and dance, on a site where we created a large, winding serpent representation of stone and paint on a hillside overlooking the swollen Gila River.

Harold Littlebird, performance, Hawai'i

My most memorable experience during the Arizona meeting was our visit to Snaketown, the ancestral home of the Hohokam, and the location of many ancient ruins of these river people. After we were allowed to walk around the ancient village, following our own paths of individual thought, we spontaneously joined together and began to play music using cane instruments, rattles, and flutes (see page xix). From that point, Frank shared chants and gambling game songs from his traditions, and we engaged in an impromptu "stick game" celebration. We later found out, after our robust chanting and game playing, that the mound on which we chose to enact our rituals was the original site of

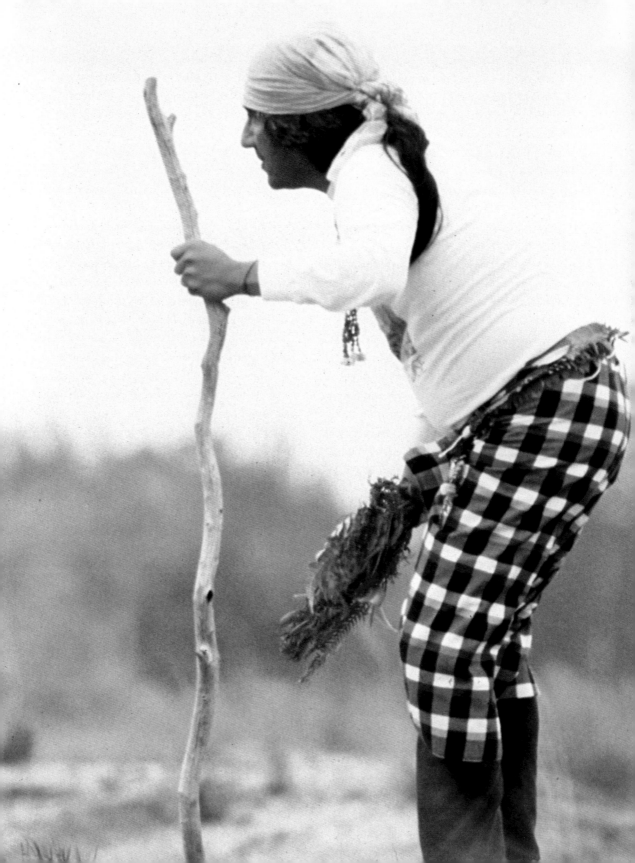

the story of an ancient gambler. The image of that gambler can still be seen in the mountain peaks west of Snaketown.

Throughout our extended travels, or medicine wheel journey described by the four cardinal directions we used as our reference points, I became increasingly aware of our group's collective energy. Everywhere we went, a sense of wholeness followed. We were blessed, welcomed, and allowed the freedom to create as artists, sharing the commonality of story, meditation, and prayer with people and communities no different from our own.

Always, at the onset of our creative work, there were many group offerings of thankfulness, as well as individual prayers for a safe journey. In this sense of asking, our collective energy became a source of inspiration and guidance in all our work, be it paperwork or actual group collaboration in artistic expression, each of us adding his or her own personal power and energy to the benefit of the whole. A gathering of strengths—physical and emotional—spiritual empowerment through hard work, seemed to be achieved each time we asked for it collectively. Our sojourns were not always stern and somber: a communal bonding through humor and laughter was a constant. Teasing each other, so we didn't take ourselves so seriously, was the balance that created a focus in all that we shared or encountered. Humility helped us remember global truths of caring and compassion.

During our short stay on the Stoney Reserve, we met with Nakoda Chief John Snow. He shared some of the history of how his people came to the area, and the vigilant struggle that continues against the constant encroachment by non-natives on their sacred sites. The natural beauty of places like the hot springs in Banff and the sacred Peyto Lake and Peyto Glacier are being despoiled by pollution from tourists.

This issue of violation and intrusion continually arose in the conversations we had with people at all the sites where we visited and worked. Kindy Sproat, in Hawai'i, as well as several other elders of the island, also talked of the encroachment on ancestral homelands by non-natives and the lack of respect shown by tourists for various shrines and temples still frequented by his people. In Arizona, Joseph Enos, our guide to the Gila River Reservation, expressed his concern over the younger generation's lack of respect for tribal identity and expression. He gave our group moral encouragement to be proud of our native identity and heritage. He even led a guided meditation for several of us to be courageous in our individual journeying.

Wherever we've traveled, we have been guided by all the ancestors, after humbling ourselves through prayer. I have been very grateful for the wisdom of our own group's elders. Their life experiences have added much meaning and well-being to my own personal journey.

*Notes*

1, 2. Lyrics from "El Rito Memory," in *The Road Back In*, copyright Littlebird Studios, 1987 (used by permission of the author).

3–6. Lyrics from "Rebel Crow Memory," previously unpublished and unrecorded, copyright Harold Littlebird, 1988–92 (used by permission of the author).

# Harold Littlebird

## Music and Poetry Performances

✺ Keynote speaker and performer, National Community Education Association Conference, Nashville, Tennessee, 1993

✺ University of Colorado, Boulder, 1991

✺ World Future Society Conference, Boston, 1987

✺ Los Angeles Natural History Museum, 1985

✺ Houston Center for the Performing Arts, 1982

✺ Robert Redford's Sundance Film Institute, 1981

## Film and Video Performances

✺ Narration of *Organ Pipe National Monument* videotape, U.S. National Park Service, 1992

✺ Guest narration of *The Legend of the Indian Paintbrush* on Public Broadcasting Service's *Reading Rainbow*, hosted by LeVar Burton, 1992

✺ Featured in Chaco Culture National Historical Park's *The Sun Dagger*, Bullfrog Films, 1982

## Musical Recordings

✺ *A Circle Begins*, Littlebird Studios, 1985; *The Road Back In*, Littlebird Studios, 1987

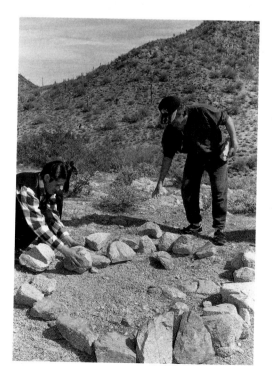

José Montaño and
Harold Littlebird,
Snaketown,
Gila River, Arizona

# José Montaño

José Montaño (Qulla [Aymara]) was born in the small highland village of Incalacaya, in the department of La Paz, Bolivia. At an early age, he learned from his elders to make and play a wide variety of traditional wind, percussion, and stringed instruments. In the late 1960s, he began his professional career playing with several traditional musical ensembles in Bolivia. He taught wind and stringed instruments at the Academia de Musica Mauro Nuñez in La Paz, and, in 1972, was a founding member of Grupo Aymara, Bolivia's premier folk music troupe and a leading force in the revival and promotion of traditional Aymara and Quechua music.

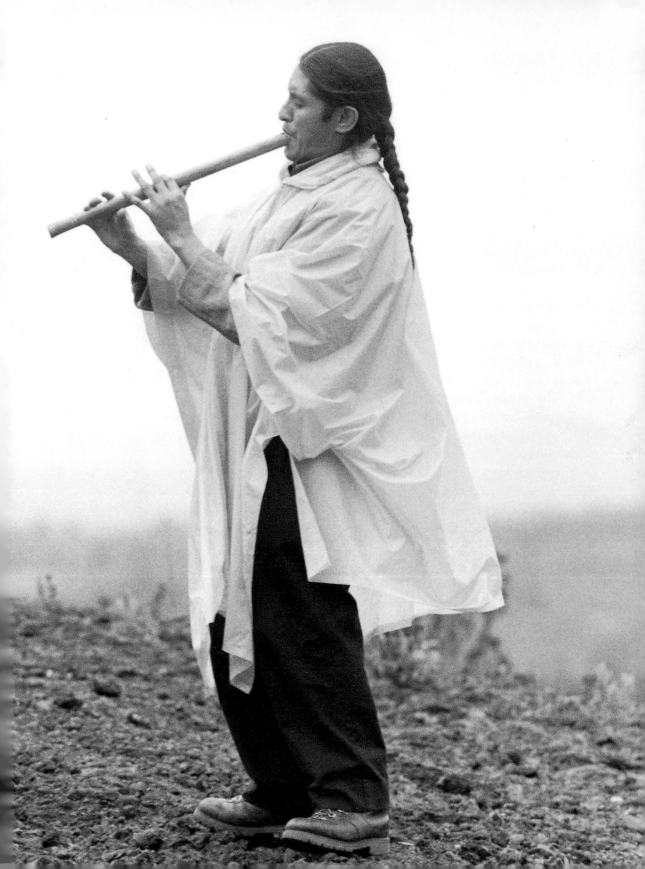

Music is very important in Bolivia. Besides music from outside—like rock, classical, and jazz—we also have two main kinds of Bolivian music. One is a type of pop music that is very Bolivian in character but is blended with, and influenced by, European culture (and is thus called *mestizo* music, which refers to a blending of traits). It is popular in the cities and with people of mixed culture. Native music, by contrast, has roots in the rural countryside and is played by Bolivians who are culturally Indian. Although the majority of Bolivians have Indian blood—mostly Inka (Quechua) or Qulla (Aymara)—Indians are on the bottom of the social ladder, and our native culture is devalued. In the cities, Bolivians who are Indian by blood, but who value and adopt European cultural traits, are called mestizos.

I grew up in Incalacaya, a village in the countryside where native music is a part of life. In the evenings I would lie in my bed, listening to the music playing late into the night. I was fascinated by this music and the musicians, and even though I was quite young, I wanted to play it myself. The first time I played an instrument was with my friend, who had a whole family of *tarkas* (wooden flutes) at his house that had not been played for a long time; I still have some of those tarkas.

When I really began playing seriously, we had moved from Incalacaya to La Paz so my brothers and I could go to grammar school. I learned to play *sikus* (panpipes) with my friends, and we formed a group and played native music for fun. At the same time, I began to play mestizo music with other groups. We played mestizo music in *peñas* (Bolivian nightclubs), in theaters, at festivals, on the radio, and sometimes on television. We imitated famous mestizo musicians and yearned for their glamorous lifestyle. When these musicians performed in theaters and peñas, they were treated differently from the musicians who played native music. Mestizo musicians used the nice

dressing rooms, while the native musicians had to change in restrooms and hallways. Generally, native musicians opened concerts for mestizo players and filled in during breaks.

Even in La Paz, I could not forget the native music of the countryside. I always wanted to touch the native instruments. Sometimes my father would give me a bit of change to spend, and I would go to a place where they sold wind instruments and buy flutes like other children bought candy. I watched the instrument-makers play native music and make instruments for native musicians. I recall one old man who was blind in one eye. He was gruff and not too friendly, and most people did not want to deal with him, but he interested me. He eventually became my teacher, and I would sit by him quietly and avoid interfering with his work. The instrument-makers all came to know me; they still ask about me, make instruments for me and my group, and provide us with materials to make our own instruments.

During the time when our group was playing mestizo music, some of us talked about native music. It is communal music—played for the good of a community, not to bring fame to an individual. The lifestyle of a mestizo musician is individualistic and competitive; the idea is to become famous through entertainment. Mestizo music is sung in Spanish, and the songs are about love: unrequited love, deceptive lovers, and broken hearts. They are fleeting songs, popular today but soon gone and never heard again. By contrast, our native music is part of our total culture; it does not exist just for entertainment or to turn musicians into stars.

My friends and I began to analyze the content of native music and discovered that we were looking at our cultural roots. The native music comes from our ancestors; it stresses native values. The mestizo music is European-influenced and stresses introduced

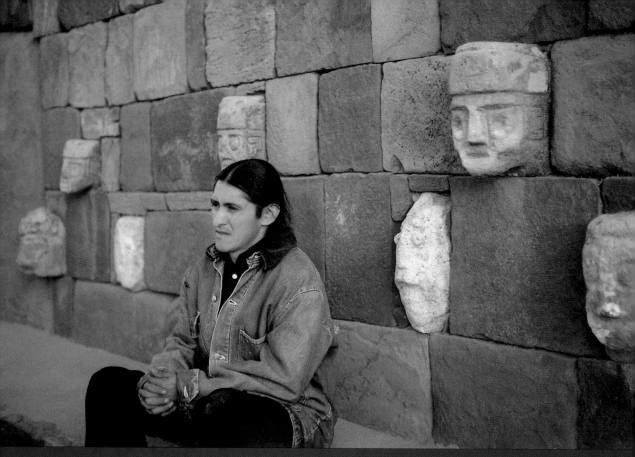

Photograph by Martha Kreipe de Montaño

José Montaño at
Temple Kalasasaya,
Tiwanaku, Bolivia

José Montaño,
performance,
Hawai'i

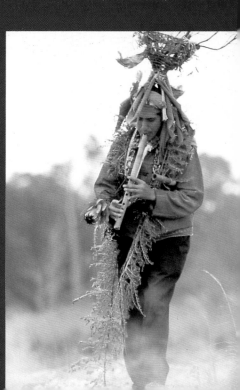

values. Our history is reenacted through music and dance. The music also contains messages from our ancestors about nature—planting, harvest, animals—and about revering our elders and children. It expresses the hopes and prayers of the community. The melodies are handed down from one generation to another and are reinterpreted, but the basic music and message remain the same. As we explored our own musical tradition, we began to have a new consciousness about ourselves, our parents, and our grandparents, and to appreciate our own language and culture.

In 1972, we decided to form a musical group to promote and record native music. We called it Grupo Aymara, in honor of our native heritage. Through music, we wanted to make Bolivians feel proud of this heritage. In Bolivia, there is a general denigration of Indians and all things Indian; "Indio" is a dirty word. Even though most Bolivians are Indian, we are taught to value European history instead of our own; one way to maintain control over a people is to take away their history. But this does not mean we are not Indian—we still have our blood. When my neighbors asked why I dressed like an Indian, it only made me more determined to identify with my heritage through native music. The Grupo Aymara has been playing and recording music together for more than twenty years, and we will continue, because our music makes us proud.

Throughout my childhood, I heard stories about ancient cities of stone. I was always fascinated by these cities, and my childhood fantasies were fueled by the stories. Later when I traveled, I looked for these cities, but never saw them. When I grew up, I went to a village called Tiwanaku to attend a Qulla community celebration. The people of Tiwanaku live near the ruins of an ancient city built long before the Inka empire. The ruins consist of stone temples and monumental stone sculptures. The carvings at

Tiwanaku are a tangible but mysterious manifestation of the ideas and wisdom of the ancients, and a link with our past. The philosophy of the ancestors is contained in these carvings. It is based on a spiritual relationship with nature and an ideal that emphasizes a strong sense of community. The instruments we use today were also used by our ancestors. Like the carvings, the music expresses the ancient philosophy that guides our lives in the present and projects us into the future. My mission is to teach through music a love and respect for nature and the importance of cooperation among people.

The design of the exhibition *This Path We Travel* reflects native philosophy in its emphasis on elements of nature, the solstices and equinoxes, and cooperation and creation. It focuses on darkness and light, creation and death, the sacred and the profane. We artists from the four directions are all different. Yet despite our different languages and customs, we share common beliefs. For example, we envision the past as being in front of us, because we can see it, and the future as being behind us, where it can't be seen.

Interacting with the other artists and the native people at the four sites—medicine men, fellow artists, chiefs, and elders—made me realize that our philosophies are connected. We believe that we are only a small part of the whole universe. At our gatherings, we always prayed, asking permission to create our art based on the traditions of our ancestors and for help in uniting all the artists—to make us all of one mind in our efforts. We did this in the hope that it would enable us to communicate a unified message to those who see the exhibit.

Native American art is not for entertainment; it is part of our sacred system. It is important to understand our philosophy, which is integrated with our supernatural beliefs. So much of our everyday life is involved with the sacred—that which follows the

rules of the Creator. We must look for ways to share this aspect of our culture. If we don't show it, we leave out a lot. The sacred is important, and yet we profane our own traditions by exhibiting them. Yet even though the sacred is not for public display and we must show respect for our ancestors, how can we share our traditions without showing the sacred? To communicate to the audience, we are obligated to break the rules.

Today Native Americans walk in two worlds. We dress and speak like anyone else, but inside we carry the traditions of our ancestors. People ask us, "Are you really Indian? Can you make rain? Where are your feathers?" Some people have lost touch with their past—they have cast it off intentionally or have been drawn away from their homeland for various reasons. As Native American artists, we wish to communicate that although we live in today's world, we are aware of our heritage, and we carry this knowledge with us. We are proud of our traditions.

Sometimes there is tension between our traditional ways and today's world. When we were working on this project, for example, we recorded everything on video and with photographs so we could document the process and perhaps use the photographs and video footage in the exhibition; but the camera affects artistic creativity and privacy. We also had to create this art within a system of deadlines and timetables— fitting creation into a schedule. This conflicts with our work as artists, because we need freedom to create. The work may take one second, or perhaps one year. At one time, native people planned their activities according to the rotation of the earth, but today many of us do not follow these rules. Many of our problems today may be in part because we are no longer guided by the seasons in this manner.

Ultimately, *This Path We Travel* is about sharing. We wish to make all people a part of the experience, to share with them our thoughts on subjects we feel are important. Art is a two-way experience, and this exhibit is designed to be a cooperative effort between artist and viewer. When people see it, they will understand that creation, respect for nature, and respect for the values of our cultures endure.

The music and instruments I used in this project belong to my ancestors. I would like to express my profound gratitude for this inheritance.

# José Montaño

### Recordings

✪ *Aliriña*, cassette and compact disc, Chicago, 1991

✪ *Pachamama Project*, cassette with booklet, New York, 1988

✪ *Jacha Marka*, Grenoble, France, 1988

✪ *Concierto en Los Andes de Bolivia*, RCA\ Victor, 1973

### Soundtracks for Documentary Films

✪ *Home of the Brave*, Film Project, Inc., USA, 1984

✪ *Inmigración de Ilario Condori, Producciones Proinca*, La Paz, Bolivia, 1980

✪ *Las Ruinas de Iskanwaya*, Producciones Ukamau, La Paz, Bolivia, 1979

### International Tours

✪ United States and Canada, 1980, 1983–84, 1988, 1990, 1992

✪ France and Belgium, 1980, 1982–83

✪ Japan, 1991, 1993

# Soni Moreno-Primeau

Soni Moreno-Primeau (Aztec–Maya) is a singer-songwriter who performs regularly with the singing group Pura Fe and Soni. She was raised by her two older brothers, and until the age of eighteen, was unaware of her Indian heritage. She notes that this knowledge made her a stronger person. Moreno-Primeau studied at the American Conservatory Theater in San Francisco, which led to a professional career in the performing arts. Most of the songs she performs with Pura Fe and Soni are original compositions based on her own experiences. The group draws its inspiration from traditional music and languages—they have used Micmac, Tuscarora, and Zapotec in some of their songs. Moreno-Primeau explains, "When I sing, I am the voices of my ancestors."

My birth name was Carmen Moreno; I was born in Sacramento, California, to Gregoria López and Jesús Moreno. I am Aztec–Maya. I lost my father when I was two, and my mother when I was eight. My two older brothers, Salvador and Robert, helped raise me. I grew up in the town of Fairfield and later moved to Hayward, California. Even though we were called "wetbacks," a slang term for Mexicans, I never felt any shame. Only when I was older did I realize this term had a negative meaning.

When I was very young, my family worked in the field picking various seasonal crops. This was the best experience I could have had as a child, because there were no boundaries: I was carefree and could see the cycle of growth starting with the blossoms in spring and the fruit—apricots, peaches, pears, grapes, and walnuts—that summer brings.

I remember the land—the Napa Valley and Fairfield—as beautiful open country with very little development. Now it has all changed. People cannot grow what they used to. The farms are being taken over by developers and machinery, and people are losing their way of life. In many areas, big money is destroying timberland, including redwoods, and housing tracts are replacing land where crops once grew. There is something lost when there is no more open land; we have to take care of it.

My experience as a teenager was different. Now, living in the city, I had boundaries. My willful nature led me to leave home at seventeen to complete my education at Berkeley. I found there were things that my brothers could not help me with or didn't know how to talk to me about. I lived with a woman guardian at school. When I was eighteen, I learned about my Indian heritage from a discussion with my older brother. It had been kept a secret due to the shame and denial our family felt. My father identified with his Indian heritage, but he was an orphan. When my mother married him, her parents did not like the idea that he was Indian. Learning I was Indian gave me a place; I belonged. Proud of my heritage, I told my friends, "I'm an Aztec." They said, "Oh no, that can't be; they're extinct." Every time I learned more about my heritage, it made me stronger.

About this time, I was cast in my first professional acting role. It was the beginning of my career in the arts. I had always been interested in music—mostly what was popular at the time. In high school, I got involved in theater because I enjoyed it, not because I seriously thought of it as a career. It was a bet from my science teacher, who didn't think I'd be brave enough to audition, that got me involved in professional theater. I never really expected to make it, but I did, and ended up in the musical *Hair*. I had always secretly wanted to be an actress. Drama was like therapy for me, so the chance to express myself on stage was like my secret life come true. Not only did I get paid for dancing and singing, I could put it out for the universe to catch on to it.

While at Berkeley, I was also studying at the American Conservatory Theater in San Francisco. *Hair* was somewhat controversial because it affirmed the hippie lifestyle in San Francisco at the time. Many in the cast were street people with no training. The cast was actually a politically active group. We honored anti-war protestors' calls for a Vietnam War moratorium by going on strike for a night. Although the producers brought in actors from neighboring productions, when we explained why we were on strike, they too honored it. In the late sixties and early seventies, when a group of Native Americans seized Alcatraz Island, we asked for audience donations to help with food, water, and other supplies for the protestors.

While on the European tour of *Aladdin's Lamp*, after more than ten years of being in the theater, things were changing for me. I had taken my six-month-old son on the tour, and it was difficult. I knew I couldn't afford to continue to do things in the old way. Wanting to do something different, I co-founded a singing group with my partner, Pura Fe, called Pura Fe and Soni. Most of our material is original music that uses our own experiences to comment on contemporary times. We use traditional instruments, like hand drums and rattles, and we sing some traditional songs in native languages. We perform all over the community. The music we sing is about everyday life and work. If I had to label myself in some way, I would call myself a singer-songwriter. Singing is part of my life. When I sing, I am the voices of my ancestors.

Through my creative work, I've met people from all over the country, which has made me feel spiritually closer to them and to the land. This source of inspiration, along with music, has enabled me to know myself better and given me a purpose. I have worked with children in schools. This is important because there is so little correct information on indigenous peoples being taught. By performing and answering the questions of the students, and sometimes even the teachers, I can help change their perspectives. Very few people have any idea where their food comes from, how it is harvested, or how it gets to market. So I share my early experiences with them. We mostly perform in middle schools, and sometimes in high schools. We also perform on Indian reservations.

My life experiences have taught me that sharing with my own children is more fulfilling than anything else. As a parent, I try to give my children a greater appreciation for who they are, and I express my emotions honestly and openly, explaining that it is okay to be angry or have feelings that differ from others'. While I had to grow up with secrets and hidden emotions, I have been able to tell my children about their backgrounds openly and joyfully. Because I had the chance to learn about life myself, I've been able to help my children make connections with the world and have faith in themselves and life.

The artists of *This Path We Travel* came together because it was meant to be; the timing was right and so was our working together. We are all from different nations, yet it's really one nation, and we have become like a family. We have grown closer because we respect one another and give each other the space to express ourselves. The locations we visited are alive with the spirits of our ancestors. We moved our ancestors with every song we sang, with every note we played, and with every creative piece we made on the land; our work moved the earth and our ancestors heard it. I think we are the generation that will start this chain going again, because it has been still for a long time.

When we visited Hawai'i, I saw things I had not seen before. The forces of the volcano, new life-forms—these are very powerful. Creation was very strong there, the land is still growing, and we saw it before our eyes. The traditional roles of male and female associated with the land reminded me of the universal need to be in balance, and how the land helps us keep that balance.

At Gila River, I found similarities in the symbols used by the tribe and those used by the Aztecs. Walking in the place of the serpent in the village of Snaketown was walking on home land. Being greeted by a coyote when we first arrived made our welcome to the land and the animals real. I felt the power of the group we represented as a single power. I honor the place with these words:

## THE GILA RIVER

Walk Softly
  As not to wake them.
Our brother Coyote
Reminds us,
With Greetings.
Welcome
  eat, play,
    sing,
      tell the stories.
  My brothers and sisters.
For it's been
A long time
Since
We've come together
In peace
With
  all
    of our
      Relations.

shouldn't be there—I am thinking of the masks and burial moccasins. The solution, I thought, might be that the museum and the artists were all part of the same project, and perhaps through our different interpretations and expressions as artists, we could help change things.

I feel the need to reaffirm the designs of the early *huipils* (women's traditional blouses) in the exhibition. In the old designs, the serpent and the four directions were important. About fifty years ago, however, the church deemed the designs heathen and savage, and made people take them off and use flower designs instead. The church attempted to take away the power of the people. In *This Path We Travel*, I intend to use the traditional designs to speak for the power of tradition.

Soni Moreno-Primeau,
performance,
Hawai'i

When we were in New York, I thought about the fact that many people don't think there are Native Americans here. In fact, we live in all the boroughs of the city. I am an active board member for American Indian Community House, which assists native people living throughout our area, as well as native visitors to our community. I see many Indian people travel through this area for social events and other reasons. For me, it is a place I work where there is enough to keep me busy. But it is also bad, stressful living—many are hoping to leave. I personally would like to be in a more natural area. The way I keep my sanity is by going to visit friends at various reservations. This rejuvenates me enough so that I can come back to the city to work.

When we viewed the Heye collection in New York, I had the feeling that much of the stuff

Mass media are still stereotyping Native Americans. In 1992, I was part of a production in New York City called *Blood Speaks*, a collaboration with Coatlicue Los Colorados, a group of native women. It was about our life experiences growing up in America, and how prejudice and racism condition us. When I was growing up, Mexican Americans were not allowed to participate fully in society because others wanted to keep us in our place. Once when I was very young, immigration agents came to the fields and everybody ran off, including me, even though I was born here and I am Indian. The agents were trying to see if people had their papers in order, or were *braceros*, or wetbacks. We all looked the same to the anglos, though, so to them we were culturally Mexican.

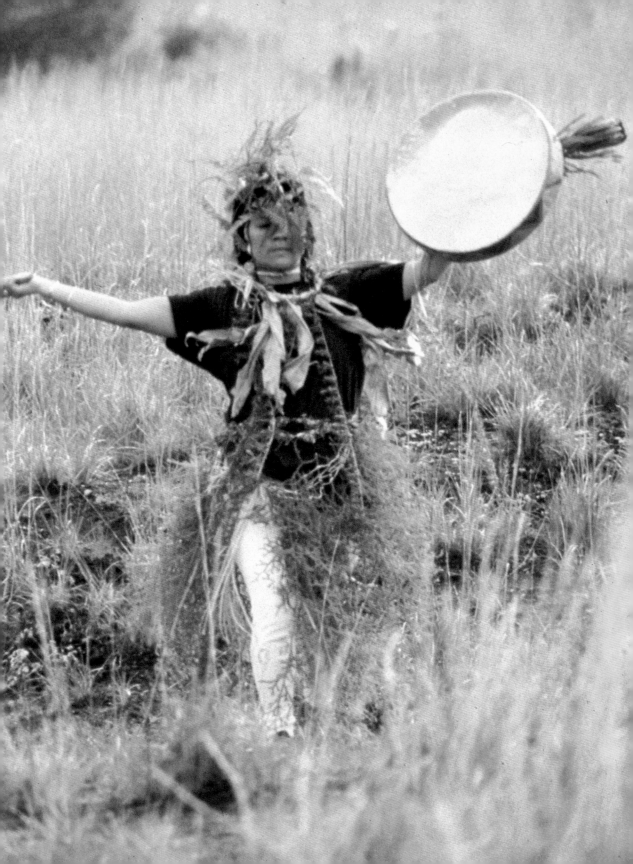

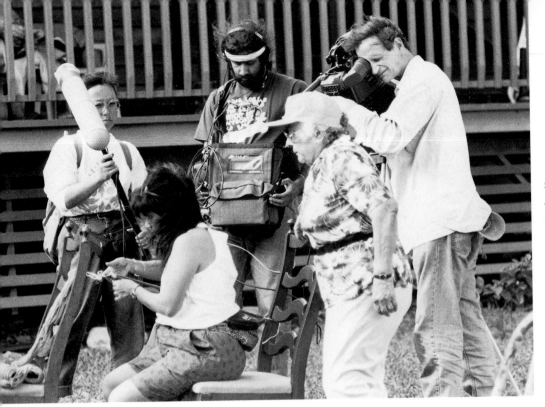

Soni Moreno-Primeau,
Josephine Wapp,
and project
documentors,
Hawai'i

Intrusions into our everyday life continue. The HUD house in the exhibition is our way of showing the conditions under which many reservation Indians live. Native American artists now must have a tribal identification card that says they are "real." The motto is: "Don't leave home without it." It is one more way of keeping track of native people. There seems to be a need to control Native Americans without thinking about what repercussions this has for us. A paradox of the project is that although there has been an emphasis on the natural beauty of the places we have visited, many of these locations—Gila River, Hawai'i, Canada—are in national parks or are restricted areas. We had to get permission to visit there, and this evoked a sense of boundaries and control.

I like the idea of the Creation area of the exhibition—the feeling of space with stars, darkness, and sounds—of walking into Creation where everything begins and the roles of male and female are recognized. Everything here is sacred. All of us in the group seem to have this understanding of what is sacred, and there is respect for the importance of creation.

I hope people who experience *This Path We Travel* will gain a new perspective about themselves and how they relate to the world, and leave the exhibition with a new understanding of the native view of today's world. It is an important project, because it relates to a prophecy you find in many nations. In the prophecy, native people gather and come together to work for peace and save the earth. It's the beginning of the healing process. We're doing that here, I really feel that. I think this family is doing good work.

# Soni Moreno-Primeau

**Dance**

✪ Gibson Girls, *The Copasetics*, 1973–78

**Theater**

✪ *Blood Speaks*, American Indian Community, with Coatlicue Los Colorados, New York City, 1992

✪ *Aladdin's Lamp*, La Mama Annex Theater/ European Tour, 1982

✪ *Hair*, Geary Theater, San Francisco, 1969–71

**Music**

✪ Beyond Survival Conference, Ottawa, 1993

✪ Ban the Dam Jam, Beacon Theater, New York City, 1992

✪ Next Wave Festival, Brooklyn, New York, 1992

✪ Clear Water Festival, Hudson, New York, 1991

**Costume Design**

✪ *Spider Woman*, New York City, 1991–93

✪ Coatlicue Los Colorados, New York City, 1991–93

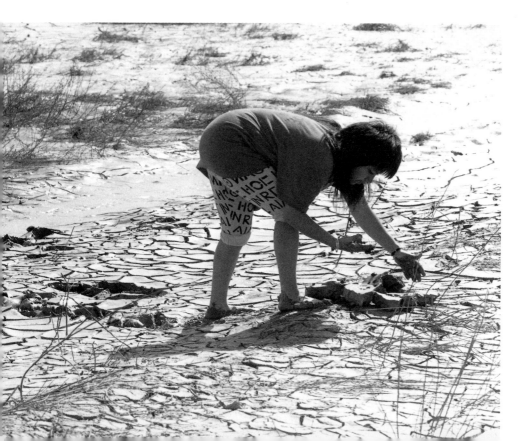

Soni Moreno-Primeau,
Snaketown,
Gila River,
Arizona

# Dan Namingha

Dan Namingha (Tewa–Hopi) is a painter, printmaker, and sculptor who lives and works in Santa Fe, New Mexico. He began drawing and painting as a young child on the Hopi Reservation in Polacca, Arizona. He also studied art at the University of Kansas, the Institute of American Indian Arts in Santa Fe, and the American Academy of Art in Chicago. Namingha's art, based on traditional Hopi themes, is to him "a way of expressing strong feelings relating to my environment and culture which gave me the foundation and freedom to create."

Drawing and painting was a natural part of my childhood. I grew up in a family of artists living on the Hopi Reservation. My great-great-grandmother Nampeyo was a famous potter, so I was exposed to that while growing up, although I never went in that direction—doing pottery. That mainly was what the women did. I guess my thoughts were on painting, but I never really got that experience until I went to school right there on the reservation. We had a government school, so that's where I went. And that's when I was first introduced to many kinds of artistic materials and to painting, around the age of seven. From that point on, I never let it go.

There was a teacher at the school who taught courses like arithmetic, but she was also a painter. She saw natural artistic ability in a lot of the kids at the school, so she provided materials and reserved time when we could paint. That actually encouraged me to get up in the morning and go to school.

I just kept painting over the years. When I was in the tenth grade, I was given a scholarship to go to the University of Kansas to study art. That was the first time I had left the reservation and gone that far away. It was a good experience, because I learned about different styles of art like abstraction and realism. As I got older, I realized that abstraction had been around quite a while among Native American people. Some of the abstract expressionist painters, like Pollack and Gorky, were inspired by Native American designs, as well as designs from other indigenous cultures. Picasso was very influenced by African styles. But these artists didn't understand the meaning of the designs. They saw them as abstract forms that inspired their sense of design, and incorporated that into their work.

Today, as a contemporary painter myself, some of my mentors were abstract painters of that era; they have influenced my work. On the other hand, I've used my own traditional designs, knowing their significance and meaning, and incorporated them into my art. Sometimes I combine the designs so that there is a sense of abstraction, yet still a deep meaning in the work that comes from a deep place. It's not just a superficial "decoration," but art with meaning.

Several years ago my grandfather, who passed away not long ago, went to one of my art exhibitions. He was in his late nineties, but he went to the exhibit and viewed all the work, then came back and went through viewing all the work again with me. He pointed out all the pieces he understood and what they meant, and he was right on, in spite of the fact that the work was very contemporary and very abstract. He knew where I was coming from and he could understand it. He thought it was interesting that images that we see in one way as traditional members could be changed into abstract forms, while still retaining their meaning, still making the same statement. For him, it was a positive thing.

For the Hopi people and Pueblo culture, we still hold on to our traditions very strongly. Much of it is hidden away from foreign eyes, and we still practice it. But we are also a changing people—all Native American people are changing—and we are individuals as well. I think this also applies to artists. When you're in a ceremony, you're a group, a unit. You're all one. Your thoughts are to one point and for one purpose. At the same time, you're also an individual within that group. It's like a group of students in a classroom when the teacher reads a story to the class. All the students in that class are listening to the story. They're all tuned in and locked in to that story, but as individuals, they all have a different visual image in their minds—a different picture of the story. That's kind of how I see myself. When I'm involved in a ceremony, my thoughts and chanting are focused on one point with the group. As individuals, however, we all see the image differently. And

Dan Namingha,
performance,
Banff,
Alberta, Canada

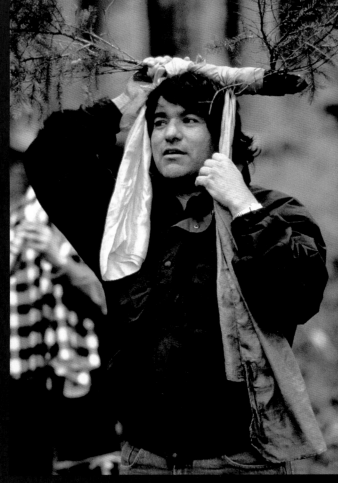

Sphere installation,
Banff,
Alberta, Canada

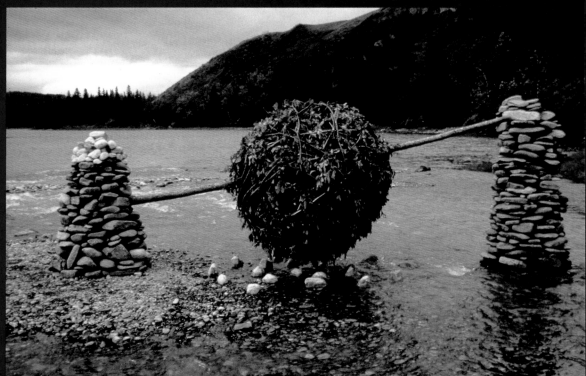

that's how I express myself through my work, as an individual.

In traditional Native American life, whenever there was an event, people worked together to make it happen. And so in a sense when I was approached about the *This Path We Travel* project, this collaboration of Native American artists from different parts of the country, I thought about it and I was intrigued because it involved so many different kinds of artists. Not only visual artists, but writers, performance artists, and musicians. We are challenged to create an exhibition through a collaboration with all these different media. I believe the ancient art of cooperation in our collective backgrounds will help to make this project a positive one. Traveling to different sites for our meetings and installations, we shared our views, thoughts, ideas, and always an appreciation of humor. I feel this has created a natural bond within our group, commonly shared among Native Americans.

Banff, Alberta, was the farthest north I had ever been in my life. I was very impressed with the mountains and the landscape. Mountains are very important to the Hopi and Pueblo people. In New Mexico and Arizona, there are certain mountains where we have our shrines. So going to Canada and seeing the mountain peaks there was very powerful. It's also the first time I'd seen a glacier.

The original installation of the willow sphere we created in Banff was based on a Hopi origin story about the emergence of the Hopi people (see page 95). According to prophecy, we are now in the Fourth World and are merging into the Fifth World. Spider Woman brought the people into this world from the center of the earth. Her twin grandsons are guardians of the

earth—one watches the land, the other the water. So we constructed one column of rocks in the water, and one on land. We put the sphere between them with the pine pole through the center, and rested the pole on those two columns. We made the sphere out of natural materials, so it would eventually go back into the environment.

In a sense, the sphere installation was our gift to the Stoney people. It represents the idea that we all come from one source, the center or womb of this earth. I will never forget the warmth of the native people in Canada as well as Hawai'i, and the beauty of their land. The hospitality they so unselfishly shared with us was wonderful.

Down through the centuries, art has always been a strong form of communication. Whether positive or negative, art has communicated and sometimes made a lasting impression on us. Other times, it has told us of our beginnings and the evolution of our thinking. This enabled us to put ourselves into perspective. By utilizing various forms and media, we as artists are fortunate to have the ability to express our thoughts and ideas about this world. Sometimes our work begins with uncertainty, but that is part of the creative process and the evolution of art.

As Native Americans, we are part of that continuous evolution and change; socially, politically, culturally, and spiritually. In a much broader picture, what is the future of all indigenous people throughout the world? And also, what is the future of this planet and the human race that inhabits it? Through technology, we are able to communicate instantly, and even to travel to other planets. Is our technology moving faster than we can morally control? There are positive and negative aspects to this new knowledge and power.

One can only wonder where and how we will exist several hundred years from now. I feel as a Tewa–Hopi person that it is vitally important that we have a universal understanding and respect regarding our planet, mainly for our survival and existence as a human race in spite of cultural diversity and differences. We may then have positive hope of merging into a balanced Fifth World and on into the millennium.

# Dan Namingha

**Exhibitions**

✪ Fogg Museum, Cambridge, Massachusetts, 1994

✪ Nevada State Museum, Las Vegas, 1992

✪ Palm Springs Desert Museum, Palm Springs, California, 1991

✪ National Academy of Sciences, Washington, D.C., 1988

✪ Heard Museum, Phoenix, Arizona, 1987

✪ The Museum of Modern Art, Osijek, Yugoslavia, 1986

✪ Kunstlerhaus Gallery of Fine Arts, Vienna, Austria; Amerika Haus, Munich, Germany, 1984

✪ Amerika Haus, Berlin, Germany, 1983

✪ California Academy of Sciences, Golden Gate Park, San Francisco, 1978

✪ Orange Coast College, Costa Mesa, California, 1977

# LeVan Keola Sequeira

*LeVan Keola Sequeira (Native Hawaiian) developed a strong interest in woodcarving at a young age. His emergence as a world-class artist parallels the recent renaissance of the Hawaiian culture. Much of his time is devoted to studying the Hawaiian traditions associated with woodcarving, as well as other traditional art forms. Sequeira works full time as a traditional Hawaiian sculptor and carver. In 1975, he constructed the Hokulea and Mo`olele, two double-hulled sailing canoes. He notes that the process of creating Mo`olele led him "through a personal spiritual and cultural transformation." This experience provided the catalyst for his work in kii (Hawaiian images), which Sequeira describes as the "axis mundi of the Hawaiian world view."*

I was born in Honolulu, Oʻahu, Hawaiʻi, and was adopted by a Hawaiian family from the Kahekili and Kamehameha line. The Sequeira family of Lahaina also traces its ancestry to the Newton and Eldredge line of New England; however, my identity derives from the early days I spent with my grandmother. She taught me the Native Hawaiian heritage of our family. Although my grandmother is no longer here, her spirit and the *aina* (land) continue to guide me. I live on a piece of land that was the spiritual heart of the old Hawaiian kingdom. This land is sacred; it has always been in Hawaiian hands and my family has continuously lived here for more than one hundred and fifty years.

I was first taught woodcarving by Mr. Wright Bowman, Sr., in the seventh and eighth grades at the Kamehameha School in Honolulu. Throughout high school, I refined my woodcarving skills under the tutelage of Mr. Fritz Alplanalp. After four years with Mr. Alplanalp, I earned his recognition as the most gifted woodcarver he had taught in his twenty years at Kamehameha. I joined the U.S. Air Force in 1965 and trained as a loadmaster on a C-141 transport jet cargo plane. I spent three and a half years in the Air Force, most of which was spent flying in and out of Vietnam. Following my honorable discharge from the service, I returned to Maui and worked for the next twenty years for the Maui Police Department, from which I recently retired as a field sergeant.

Throughout my life, the values, legends, and feelings associated with being Hawaiian were nurtured by both my grandmother and mother. Although they were influenced and limited somewhat by Christian thinking, enough of the traditional teachings came through from them to set me on the path as a traditional person. My special interest in woodcarving began to appear around the age of five. My knowledge of the deeper side of Hawaiian art did not develop until the mid-1960s. At that time, I discovered that the Hawaiians accomplished the highest form of wood sculpting in the Pacific Triangle, and at that time I devoted my life to finding out why. As I have progressed, the art form has become more refined. I have learned that it is not enough to have the mechanical ability to produce the Hawaiian art form. The *huna,* or true secret, lies in the spiritual aspect of the art. This recognition inspires my everyday work.

In Hawaiʻi, the people get along together because we come from the same place. My experience has been very similar with the artists of *This Path We Travel*. We are very much like a family. At each site we visited, there was cooperation, and the work was made easier because there was lots of laughter. Our work wasn't hard, because our laughter and jokes made it easier. We came together as strangers, but our backgrounds as indigenous people gave us a common bond.

The process of the project widened my horizons when it came to my view of art. I have been channeled into certain areas of art—more on the traditional side, and sometimes moving into the contemporary—but some of my fellow artists opened my eyes to contemporary art. That's something we shared, and I've definitely expanded in that area. My traditional forms are still very traditional—I haven't gotten away from that. But my view of the contemporary side of my work is beginning to change. I can see more avenues that I could take and still remain within certain frameworks of what I consider acceptable to my culture. I'm very cautious about that, and I don't want to move too fast into the contemporary, especially when it comes to my culture.

Looking at the Heye collection allowed me to see different kinds of tools. As a carver, I work with

my hands and with tools all the time, so I related to the tools. I am interested in how to use and make them. The technical aspects of the different types of tools captured my imagination.

As a group, we have visited New York, Canada, Hawai'i, and Arizona. I have seen the areas where our indigenous ancestors lived. I have felt the binding force that enlivens people of the land. The geography may be different, but our people all relate to the land in the same way. This is what distinguishes us from Western culture.

Our contact with the native people at the sites was particularly rewarding. Meeting Clyde Sproat in Hawai'i was very important to me. We share a common language, common ancestors, and the same culture; for this reason, it was easy to relate to him. The common ancestors made us relatives, and we found that our lives had run parallel courses. Spending time with Clyde—he was able to tell me new things about Kamehameha—was a true learning experience for me.

From an artistic point of view, I noticed how each group of native people we visited related to their environment and lifestyle; these two factors have a tangible impact on their art forms. Art forms differ from area to area, but they have one thing in common—they are all formed from indigenous natural materials. These materials were then made into objects that sustained the peoples' everyday lives and enhanced their spiritual lives. Each object has a deep meaning and a connection to the spirituality of the people.

The artists of *This Path We Travel* are from different cultures and geographical areas, but we relate to life in a very similar manner. We laugh at the same things, we react to ideas in a similar manner, and we sometimes cry with a pain that is unique to indigenous people. Throughout the project we have grown together as an *ohana*, or family. We have shared with and learned from each other, and in the exhibition, we will share with others those things we have felt and learned.

# LeVan Keola Sequeira

**Art Commissions**

❂ Koa racing canoes, repair and modifications of Lehia and Koko, two Maui Canoe Club canoes, ongoing

❂ Hawaiian double-hulled canoe miniature models, sold to collectors in San Diego and Long Beach, California; Vancouver, Canada; and Maui, 1980–present

❂ *Kahuna kalai kii* (designer-carver) of a fourteen-foot ohia-wood *lono kii*, Iao Valley, Maui

❂ *Kalai kii* (carver) of two ohia-wood *kii*, Ahuena Heiau, Kailua-Kona, Hawai'i, 1980

❂ *Kahuna kalai wa'a* (canoe-maker) of Mo'olele, a forty-two-foot double-hulled sailing canoe, Maui, 1974–75

**Exhibitions/Commissions**

❂ Hana Coast galleries, 1991–present

❂ Wailea Coast galleries, 1991–present

❂ Hyatt Coast Gallery, 1991–94

**Television**

❂ *Legacy of Excellence*, Public Broadcasting Service production on contemporary Hawaiian arts, featured artist, 1990–92

❂ "Year of the Hawaiian," Public Broadcasting Service documentary on early Hawai'i, used artist's canoe Mo'olele in filming, 1989

LeVan Keola Sequeira with effigy, Hawai'i

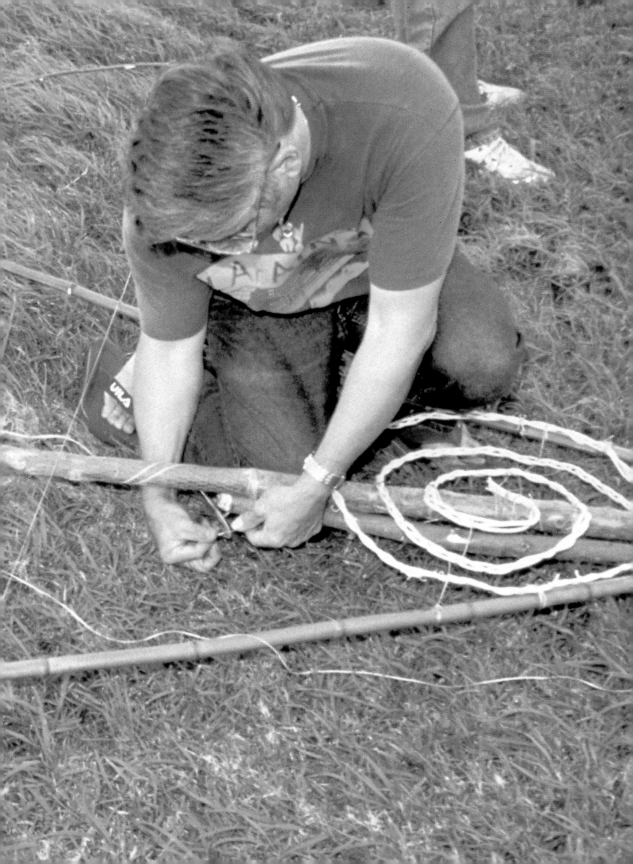

# Hulleah J. Tsinhnahjinnie

Hulleah J. Tsinhnahjinnie (Seminole–Creek–Navajo) has been a professional graphic designer and photographer since 1980. She is also known for political commentary on native issues, which is often reflected in her artwork and photography. Tsinhnahjinnie utilizes photo-collage, mixed media, and installations to address the "myth of colonial authority." She has exhibited nationally and internationally and has participated in artist-in-residence programs at such institutions as the Center for Exploratory and Perceptual Art, Buffalo, New York, and Film in the Cities, St. Paul, Minnesota. She has been a visiting professor at the Institute of American Indian Arts, Santa Fe, New Mexico; Bug-Ga-Na-Ge-Shig School, Cass Lake Minnesota; and the San Francisco Art Institute.

From the moment I arrived, I was wrapped in a blanket of creative energy, a blanket of cultural security designed by perseverance and native intelligentsia, a collaborative design created by countless relatives. What follows is the perspective from the folds of a self-proclaimed blanket Indian.

I have often reflected on the decision made by my parents to give their children native first names, especially at a time (the 1950s) when assimilation was at a screaming high point. I was gifted with the name of my maternal great-grandmother, Hulleah. I used to ask, "What kind of woman was she?" The reply was, "A woman who carried a gun." Taking on the responsibility of upholding my great-grandmother's reputation, I have chosen art to be my weapon of survival—a weapon of thought and a weapon of ideas. Who knows? Maybe things might have been different if my name had been Polly.

A strong artistic and cultural foundation influenced my formative years, as I observed Dad and his colleagues painting. According to Mom, my siblings and I mutilated countless fine sable paintbrushes, struggling to imitate Dad's painting style or that of Harrison Begay (Navajo), Fred Beaver (Seminole–Creek), Adee Dodge (Navajo), or Pablita Velarde (Santa Clara Pueblo). We were literally surrounded by the "masters."

Later, about third grade, I realized that non-Native American artists were more visible than native artists. This underrepresentation of native art added to my education, although it was not strong enough to overpower my positive childhood experiences or to discourage me. A strong artistic and cultural foundation had already been set for me before I attended art school.

The 1960s and 1970s were rather peculiar times, especially regarding native art. It was a time when contemporary native artists and white art critics proclaimed the works of "traditional painters"—the first of the easel painters, such as Pop-Chalee (Taos), Begay, Beaver, Dodge, Velarde, and my father, Andrew Tsinhnahjinnie—to be the "Bambi Style." The eagerness of contemporary native artists to join the mainstream and shed the blanket created an interesting effect—internalized racism. Absent was the culturally sensitive and politically informed perspective of First Nation artists. The artistic missionaries of the contemporary mainstream had convinced visible native artists that there was a primitive failing in the "traditional style." So denouncement became the stairway to the museums of modern art. Internalized racism works well when it becomes a best friend.

Recognizing internalized racism requires analyzing actions, analyzing positions of power, analyzing one's own goals. What if Velarde became as recognizable as Picasso, or if Pena Bonita's name became as revered as Georgia O'Keeffe's—would that be equal representation? Once the superstar status of fame and fortune is equally attained by native artists, do we say the fight for representation is over? What if the goals of the native artists are found to be different from those of the mainstream? When I consider the politics, the times, what they had to do to survive, my appreciation to the elder native artists is unending.

Many people have influenced my vision as an artist. One significant person is my paternal grandmother, Ason Tso, a woman who embraced approximately one hundred and ten years of life. Through the years, as she herded her sheep, she encountered incredible events and changes. She observed the endless shifting Indian policies of the U.S. government; she was alive at the time of the Wounded Knee massacre. She witnessed my father's being forced to leave home to attend boarding school, and later his voluntary departure to fight a war for a country that did not

allow him to vote in his homeland of Arizona until 1948. Over the years, she watched dirt roads turn to asphalt, hogans into HUD houses, and horse-drawn wagons into Ford pickups. She saw the first jet contrails in the sky over the reservation and listened as my father told her, "There's a white man walking on the moon." Grandma continued to herd her sheep.

When my grandmother passed, I flew in from Oakland to Phoenix. My sister, Miquakee, picked me up at the airport and we drove five hours north to Rough Rock. As we drove into the night, I visualized my grandmother standing in front of the hogan, greeting us—she was happy to see us.

As I think about the experiences of my grandmothers, mother and father, and aunts and uncles as native people and as human beings, and as I survey my own life, I become cognizant of the strength of native survival.

When I encounter attempts to oversimplify the native experience for the convenience of "knowing," "owning," or for "mystical exhibition," I become impatient and respond with a responsibility that has been woven into my entire life; I respond with a blanket of responsibility.

During our site visits for *This Path We Travel*, interaction with the local native communities was directed by photocopied itineraries. Video cameras constantly documented our actions. The planning meetings we had were grueling. Participating in this project presented an array of considerations: the gathering of individual artists from different geographical areas to speak in a collective voice; "the meeting of the minds"; consensus as allocated by a set budget and time line. But thinking of the artists involved, the administrators, and the camera crew, I believe the interaction of ideas, opinions, and process was a valuable experience. In spite of the bureau-

cracy and the Smithsonian's experimental atmosphere, we connected with one another. But sometimes I wonder if the process led me to become somehow a "hit-and-run spiritual tourist."

As a native artist with concerns of representation, I have been looking at myself and at the native community and asking questions. During our project planning discussions, I felt I would not be a responsible member of my community if I did not say anything about representation, and I voiced my concern that the Two Spirited Society—gay American Indians—needed to be addressed in the exhibition. I felt strongly that this issue should be addressed in the Female area of the exhibition. My comments were met with curious but cautious attention and quickly filed away. It was suggested by the others that perhaps such a subject matter would be more appropriately placed in the Profane area of the exhibition. This section includes metaphors of imbalance, the juxtaposition of sane and insane, colonial encounter and response, and issues dealing with native and non-native, among others. I did not feel that the Two Spirited Society should be represented in this area, and I wondered about the group's reluctance to represent the Two Spirited Society in the Female area of the exhibition. Were only certain thoughts and ideas deemed to be "native" allowed because they were socially palatable and went with the program?

It is no surprise that response to the Two Spirited Society has shifted from cultural acknowledgment and accepted social participation to rather civilized reluctance to acknowledge. A few hundred years of the missionization of the mind and the spiritual whitewash of native values has certainly taken place. If the presentation of ideas on the Two Spirited Society is being whitewashed, then what other aspects of native thoughts and ideas have also been baptized out of existence?

The "Indian persona" can easily be a self-imposed racism. The Indian persona can plant doubt in the native consciousness about what is native. What isn't? Who is? Who isn't and why aren't you? The Indian persona seems to have no tolerance for the Two Spirited Society, yet we are here. The illusion has no room for Two Spirited political prisoners—certainly not for Norma Jean Croy (Hoopa), who is still serving time long after her brother, sent to prison on the same charges, has been acquitted. If you are a straight male native political prisoner, there are national and international campaigns for your freedom. To me, this is a signal that the Indian persona needs to be critically evaluated by the native community.

In *This Path We Travel*, it is important to emphasize that native thought is very much present and continually strengthening. Also that native cosmology is much more complex than just "the four directions." The native experience is more than a thirty-minute documentary video or a chapter in a history book or a charismatic shaman. This is but one voice presented in the exhibition.

This project is a collaboration, and it represents the vision of fifteen artists. There are parts of what we've done that are valid to me personally, and there are other parts with which I do not agree. But hey—that's working with a group larger than one. Even though it's probably the last collaboration of this size I'll ever do, *This Path We Travel* was an essential experience in working with a large group and a larger-than-life institution.

Meeting and interacting with the other artists and the people of the communities we visited was very important, and for me, the most valuable aspect of this project.

Denise Wallace,
Josephine Wapp,
Hulleah Tsinhnahjinnie,
and Jane Lind,
Phoenix, Arizona

# Hulleah J. Tsinhnahjinnie

## Exhibitions

⊛ *Photographic Memoirs of an Aboriginal Savant*, solo exhibition, Multimedia Sacred Circle Gallery, Seattle

⊛ *Rez Dog 4 Sale & Other Ballistic Fry Bread Poems*, solo exhibition, C. N. Gorman Museum, University of California, Davis

⊛ *Watchful Eyes*, native women's group exhibition, Heard Museum, Phoenix, Arizona

⊛ *Nobody's Pet Indian*, solo exhibition, San Francisco Art Institute, 1993

⊛ *Headcount*, installation at the International Istanbul Biennial, Istanbul Municipality Nejat F. Eczacibasi Art Museum, Halic, Turkey, 1992

⊛ *Message Carriers*, traveling exhibition, Photographic Resource Center, Boston University; Houston Center for Photography; Raymond Johnson Gallery, University of New Mexico, Albuquerque; Visual Art Studies Workshop, Rochester, New York; 1992–94

⊛ *Native Photographers*, Stewart Indian School Museum, Reno, Nevada, 1990

⊛ *Language of the Lens: Contemporary Native Photographers*, traveling exhibition, Heard Museum, Phoenix, 1990

⊛ *The Photograph and the American Indian*, Princeton University Library, Princeton, New Jersey, 1986

⊛ *Indian Art Today: Traditional & Contemporary*, Albuquerque Fine Arts Museum, Albuquerque, New Mexico, 1977

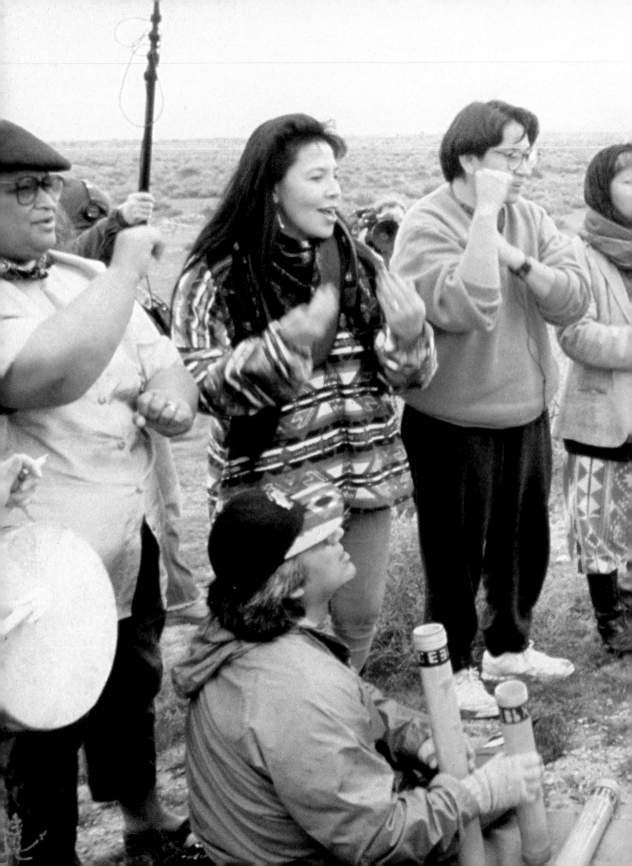

Artists (from left):
Pualani Kanaka'ole Kanahele,
Harold Littlebird,
Jane Lind,
Hulleah Tsinhnahjinnie,
Soni Moreno-Primeau,
Josephine Wapp,
Denise Wallace, and others,
musical performance,
Snaketown,
Gila River,
Arizona

# Denise Wallace

*Denise Wallace (Chugach–Aleut) is a jewelry-maker who bases many of her intricate designs on traditional Aleut mythology and symbolism. She graduated from the Institute of American Indian Arts in Santa Fe, New Mexico, and has exhibited her jewelry at the Southwestern Association on Indian Affairs' Indian Market—where she has won several awards—the American Museum of Natural History in New York, the Anchorage Museum of History and Arts in Alaska, and the Southwest Museum in Pasadena, California, among others.*

My husband and I collaborate in our own jewelry business, creating pieces out of metals, fossilized ivory, and stones. Early in our careers as jewelers, we did a lot of our own mining for stones. He would work the stones, and I would set them in metal. Our pieces were simple in design, but personal, as we remembered the area from which we got each stone. It wasn't until years later that our jewelry took on a new direction.

In the early 1980s, there were several emotional impacts on my life that had a profound influence on my designs. I was raised in Seattle, and my mother is originally from Prince William Sound in south central Alaska. My grandmother was the matriarchal figure for many people, especially her fourteen children, forty-two grandchildren, and twenty-four great-grandchildren, over whom she had tremendous influence. She was confined to a nursing home where she eventually passed on in 1985. Around this time, several of my cousins died of alcohol-related causes.

Soon after these events, I began to research the imagery of the native people of Alaska, and, with my husband's encouragement, to push myself creatively. My artistic designs took on a strong statement. I wanted to say, "This is who I am, this is where I'm from, and these are the stories of my people."

In my work, I try to represent things, objects, and people native to where I am from—the southern part of Alaska. When I visit up there, I research and study older pieces, and I look at how the people are living now, and what's happening in the contemporary world. It's a process of combining things. We take Native Alaskan stories and ideas and put them into a form that's not traditional to that area.

The designs I use in my work are not abstract, but rather descriptive about a subsistence way of life. Native ways are basic, and the most basic need is to survive. Our survival is dependent on our belief system that all things are interconnected and that we must respect these relationships. I feel all people have a need to be connected to the earth and all living things. This is a basic need for all humankind. When I design pieces, I remind myself of these connections to the earth and my ancestors. My hopes are to relay this message through our jewelry, in addition to creating something of beauty.

A lot of people ask me about the significance of using doors in some of my pieces—doors that you can open up to view an image underneath. It has a basis in traditional masks where, for example, a face might open up in the body of an animal, and inside there would be another face. You find this theme of transformation in many traditional pieces, from small carvings and fetishes to large masks. It's a way to show the transformation of the inner spirit of an animal, person, or object.

I've never felt that I was doing something taboo by creating pieces that deal with transformation. I feel that one of the biggest problems today is that we've lost those abilities to transform, to have transformation in our lives. So many of our native people leave or have been taken away from their native culture.

My work is only my interpretation on a theme, my own thoughts on something. I speak only for myself, and for what I've done and felt in my life; I'm not speaking for my people, even if others see it that way. Sometimes people assume that because you're a native person who is an artist, you and your work represent your native culture. They think we are all spokespeople for our cultures, which is not the case. We are only speaking for ourselves. How can I speak for someone else?

Similarly, sometimes people think that because I'm a native person, I know what's happening throughout

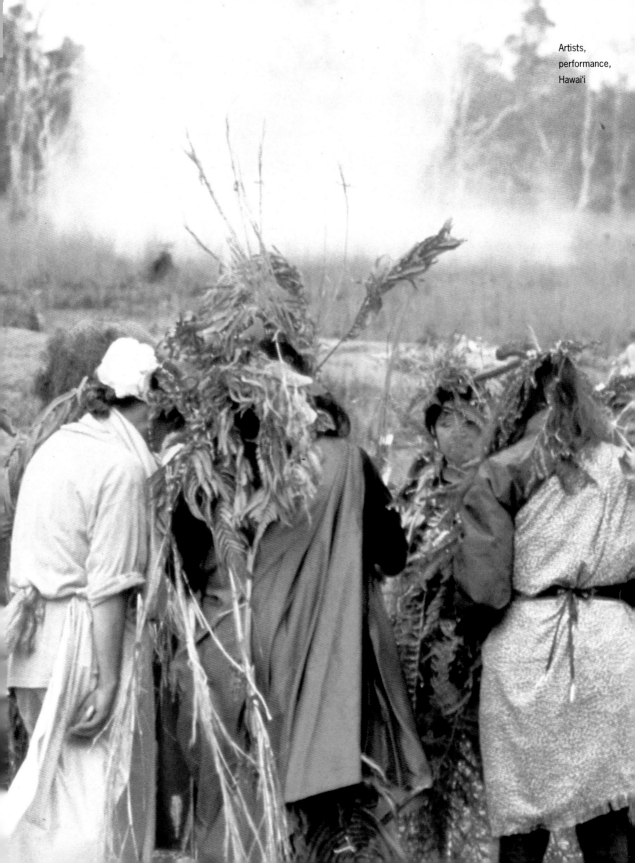

the native world, and that the same things are happening for all indigenous people. We know this is not true. There are so many things happening out there, from New York to South Carolina, to the people who are not acknowledged by the federal government, to the people who don't care whether the government recognizes them as native people. People think for some reason that it's just one, idyllic, native outlook, and that's just not the way it is.

It has been a challenge for me to be part of a collaborative effort like *This Path We Travel*. It's not easy for me to walk out with other people and be creative. I need space—a space that's all mine. I can go outside of that space and ask people questions, but I have to go back into myself to be creative. It's a highly emotional thing for me, and I have a difficult time bringing other people into that space.

Of the four sites we visited for *This Path We Travel*, the trip to Hawai'i was particularly meaningful to me. The native people there were extremely generous and made us feel welcome. We had Native Hawaiians Pualani and LeVan as part of our group, which helped a great deal. Pualani and her *halau*, or dance group, performed for us beside the crater of Pele—it was beautiful. I know we all felt extremely grateful for this experience. Afterward, we met all the dancers, and it was reassuring to discover that although these young women share the same ideas and concerns as many teenagers, they are also committed to this ancient form of dance and song; some of them had been dancing for more than ten years.

On the female side of the island, near Pele, Pualani introduced us to the various stages of life and death surrounding Pele. She told us stories about Pele's relationship with the entities of ocean water, rain, and other natural forces. The relationships all interconnect to create the beautiful islands of Hawai'i. In some areas, the lava had solidified into a mass of black terrain, and plants were emerging from the rich volcanic rock. These first plants break down the rock into fertile soil, allowing for other plants to flourish. In areas where Pele was underneath us, there was steam escaping and claiming the life of trees and other plants. It was an evolution happening before our eyes.

At this site, Jane introduced us to an Aleut tale of a young woman whose father was trying to get her to marry. She could find no suitor to her liking. Finally, she ends up with someone who turns out to be a bird, maybe a raven. In the end, she is mutilated and different parts of her body are turned into various sea animals. The Inuit have a story about this woman, and her name is Sedna or Nuliajuk. We used this story as a basis to create our own version around the volcanic steam vents (see page 115). Each one of us created our attire from the plants around us. My feelings about the performance were positive; I enjoyed working together with the others. This was the type of collaborative process in which I could feel comfortable. In a performance, you can be who you really are; it's a way to be your own individual within a group.

On the male side of the island, Arthur had created a large spider web and Doug was working on a piece having to do with the moon (see pages xxii, xxiv). Dan and LeVan created two figures inspired by the petroglyphs they had seen earlier on the island (see page xxv). As we honored the creations of these artists with various songs, we also honored our hosts for sharing their homes and stories with us.

One of the special things I learned about the Hawaiian people is how much their lives flow like their environment. It is a place where lava flows to create new land, but at the same time, envelops and reclaims lush forests. Life and death are created from the same source. Native people in Hawai'i understand that life

is a give-and-take situation, and they respect the balance of this relationship. The people of Hawai'i are a great inspiration to all of us. Their desire to be respectful of the land, their humor, their creativity, and their ability to connect and be in touch with each other, is the bond that I felt most with the Hawaiians.

The exhibition *This Path We Travel* is planned like a metaphor: a metaphor not just for the planet's life, but also for the life of the individual. The common view is one of hopefulness. As we travel along in life, with the various influences that affect us, we are constantly coming upon choices. We are in the process of choosing what is good for us, and what we do not need or want. This choice is something we, as a whole, must decide—what is good for our planet and our future generations. I like the concept. I do not know what the final impact will be, but I hope it will have some kind of emotional impact. For me, the importance of the concept is that it serves to create a unified viewpoint of the world.

Within our group for this project, native people came from all different levels and perspectives, but the one thing we all had in common was respect for the earth. Within most native cultures, there is a strong sense of "giving back" out of respect. Even those native people who advance themselves educationally or professionally still uphold that principle. It is a continued reverence for the earth and our ancestors, despite all of the loss of our culture over hundreds of years. We can look back and remember their achievements and pray for their guidance in our decision-making today.

We must also deal, however, with the despair that has affected many native communities. There is much anger and bitterness that has developed into larger social problems. Native communities today are overwhelmed with alcoholism and mental problems. I feel it has come to a time when we as native people have to face our problems and deal with them through education, rehabilitation, and reclaiming the native way of life. The strongest way to pull people out of this dilemma is through a renewal of their identity. Our future and the future of native children depends upon it.

# Denise Wallace

### Exhibitions

❂ *Voices and Visions*, lecture and group exhibition, University of California Museums at Blackhawk, Danville

❂ Exhibition in conjunction with *Crossroads of Continents*, Canadian Museum of Civilization, Hull, Quebec, 1992

❂ *Northern Images*, lecture and solo exhibition, Southwest Museum, Pasadena, California, 1991

❂ Exhibition and lecture, Gene Autry Museum, Los Angeles, 1990

❂ *Secret of Transformation*, exhibition and lecture, American Museum of Natural History, New York, 1990

❂ *Native Art to Wear*, group exhibition, Heard Museum, Phoenix, Arizona, 1989

❂ Lecture and solo exhibition, Anchorage Museum of History and Art, Anchorage, Alaska, 1989

❂ *Sun, Moon, and Stone*, group exhibition, Southwest Museum, Pasadena, 1988

❂ *Visions of Alaska*, D. W. Studio, Santa Fe, New Mexico, 1986–present

# Josephine Wapp

*Josephine Wapp (Comanche) was born in 1912 in Apache, Oklahoma. She learned traditional skills, such as how to dig herbal medicine, from her maternal grandmother, Tissy-chauer-ne, whom she credits as an inspiration to her art. She attended the Santa Fe Indian School where she learned the traditional arts of weaving and silverwork, as well as pottery from Maria Martinez, a famous potter from San Ildefonso Pueblo. Wapp returned to Oklahoma and taught traditional arts and crafts at the Chilocco Indian School, but later moved back to Santa Fe where she taught traditional techniques, Indian dances, textiles (weaving), and fashion design at the newly established Institute of American Indian Arts. Wapp has exhibited her artwork at the Indian Arts and Crafts Exhibition, Gallup, New Mexico, the Scottsdale National Indian Arts Exhibition, Scottsdale, Arizona, and the Center for the Arts of Indian America, Washington, D.C.*

My emotional connection to art came from my maternal grandmother, Tissy-chauer-ne. We lived close enough to her for me to spend many of my childhood years with her. She taught me the ways of a Comanche woman in different stages of my life. My most cherished childhood memory of her is when she took me with her to dig herbal medicines. My job was to put the medicine into a bag we carried with us for that purpose. I played around picking wildflowers, digging in dirt, picking up pebbles, and even wading in the creek while I waited for her to finish her digging. My peers and I had a special place to swim in Cache Creek, and in between swims, we would gather a clay, used for cleaning buckskin, and form the clay into round balls to bring home. Recently, I noticed this same clay from Cache Creek being sold at a trading post for $2—for a much smaller ball than the ones we used to make.

When I told my parents I wanted to pursue the arts as a career, they tried to discourage me, because they didn't think I could make a living doing art alone. To please them, I took a business course at Haskell Institute for a year, and I was miserable the entire time.

Eventually, I got my wish and attended two years of teacher training in Indian arts and crafts in Santa Fe, New Mexico, where I learned many different kinds of weaving, both traditional and contemporary. I wove on treadle-looms and hand-frame looms, and learned the art of fingerweaving. I also learned pottery from Maria Martinez, a famous potter from San Ildefonso, and her husband, Julian. After completing this course, I returned to Oklahoma where I taught arts and crafts at the Chilocco Indian School. After several years of teaching in Oklahoma, I moved back to Santa Fe to become one of the first teachers at the newly established Institute of American Indian Arts. They hired me to teach the traditional techniques of art, including textiles—all types of weaving—plus costume and fashion design, beadwork, and traditional dancing.

Since my retirement from teaching, I have been doing fingerweaving at my leisure, mostly for relaxation. I have made dance sets for dancers, when requested of me, and in addition to traditional fingerwoven items, I have created wall-hangings from naturally dyed wool for decorative purposes. I remain active in the Native American world, serving as a judge, consultant, and presenter at workshops.

I had mixed feelings joining the *This Path We Travel* project. I hesitated at first because of my age. Then I thought about it and talked with different people in Oklahoma, and they encouraged me to go ahead with it.

The project has been unique in that we're from all different areas, but I feel that we share the same way of thinking. There may be some differences, but as far as I'm concerned, I can relate to what's going on with everybody in the group. Maybe it's because I've worked with young people for so many years—naturally I can feel good about being with the younger ones. I think I'm the oldest one in the group, but it doesn't bother me; I can relate to their thinking.

Our visit to Arizona really opened my eyes. When we had the plans before us—the model of the exhibition—I began to see what our efforts were all about. The time we spent in Hawai'i was very special to me because of our performance there. What made it particularly interesting to me was that we made up all of our costumes. We made them just from what we had there. I had a really good feeling about the part I played in the performance, and the performance itself (see page 122).

It made me think of things from the past, because as a child I always did the tribal dances and participated in things like that, but I had not ever taken part in the kind of production that we did. I felt very good about it.

I haven't said very much during our talks on this project, but I've enjoyed listening to others. I realize what they are talking about, and I understand it. I think this comes from my years of teaching and listening to these kinds of ideas, and also from my background—from spending a great deal of time with my grandmother. Many of the things I learned as a child came back to me in this process; I was realizing them once again.

It bothered me a little bit when we discussed aspects of religion and spirituality we wanted to address in the Sacred area of the exhibition. I'm not a religious fanatic, although I go to church and try to live right. I respect everybody's religion, whatever kind of religion it is. I participate in religious ceremonies and tribal ceremonies, and I feel comfortable with the Indian type of religion and also the religion that I belong to.

I feel strongly about some of the things that should be included in the Sacred area. For instance, there are some locations in Oklahoma, like the Wichita Mountains in the southwest part of the state, that I feel should be covered. We should mention organizations like the Gourd Clan that use the gourd and the fan. And then there's the Native American Church—they also use these objects. If I donate something from my region for the exhibition, it would be one of these. However, I would have to ask permission to include them, out of respect.

In the Profane Intrusion section of the exhibition, I think we should talk about alcohol, which has affected many Indian people. Something else that has profoundly affected Indian people is a loss of respect. Young people have lost respect and dependability. I think a lot of it is caused by alcohol abuse and some other modern things. There are efforts being made now to reinstate some traditional values into our culture. I think *This Path We Travel* can help reaffirm the traditional Native American image of the world by pointing out some of the things that have lately affected it.

I expect to be involved in performance during the run of the exhibition. I'll be making my own costumes, too. When we were at the various sites, they just threw things out and said, "Find something in there to put on!" and that's what we did. It's kind of fun to do it that way. One of the other artists took a close-up of me putting on that garb, and they really got a kick out of that picture back in Oklahoma.

# Josephine Wapp

### Exhibitions

● Fiber Works, 1994

● Kirkpatrick Center Diamond Jubilee, Oklahoma City, Oklahoma, 1989

● Native American Indian Center Museum, Wichita, Kansas, 1979

● Southern Plains Indian Museum, Anadarko, Oklahoma, 1978

● Comparative Show of Old and New Indian Crafts (traveling show), Scotland, Germany, Turkey, Mexico, and Chile, 1968

● Contemporary Crafts (Invitational), University of Kansas, Lawrence, 1967

● Contemporary Museum (Invitational), Wichita, Kansas, 1966

● Needle and Thread Exhibition (Invitational), Museum of Contemporary Crafts, New York, 1965

● Center for the Arts of Indian America, Washington, D.C., 1964

● Scottsdale National Indian Arts Exhibition, Scottsdale, Arizona, 1964

Josephine Wapp, performance, Hawai'i

Josephine Wapp and Soni Moreno-Primeau, fingerweaving, Hawai'i

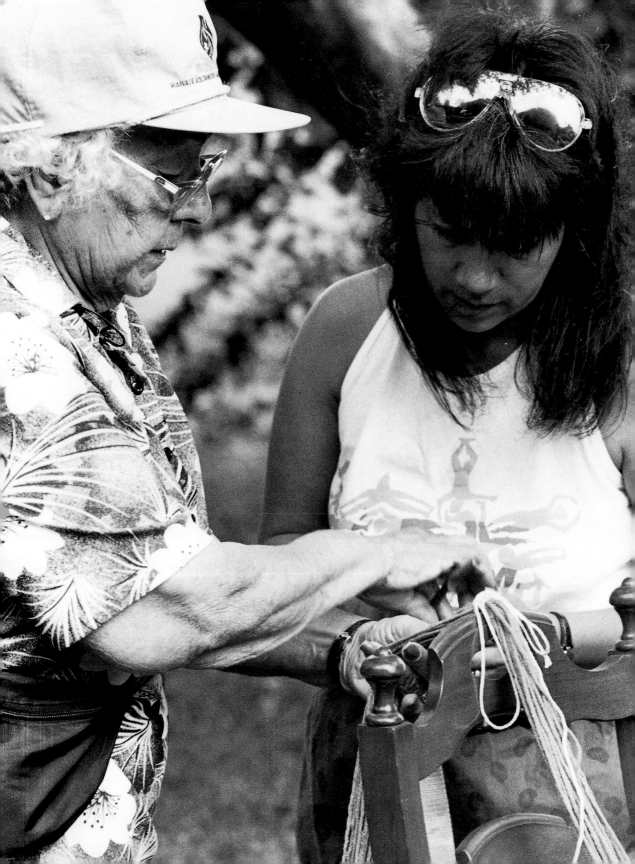

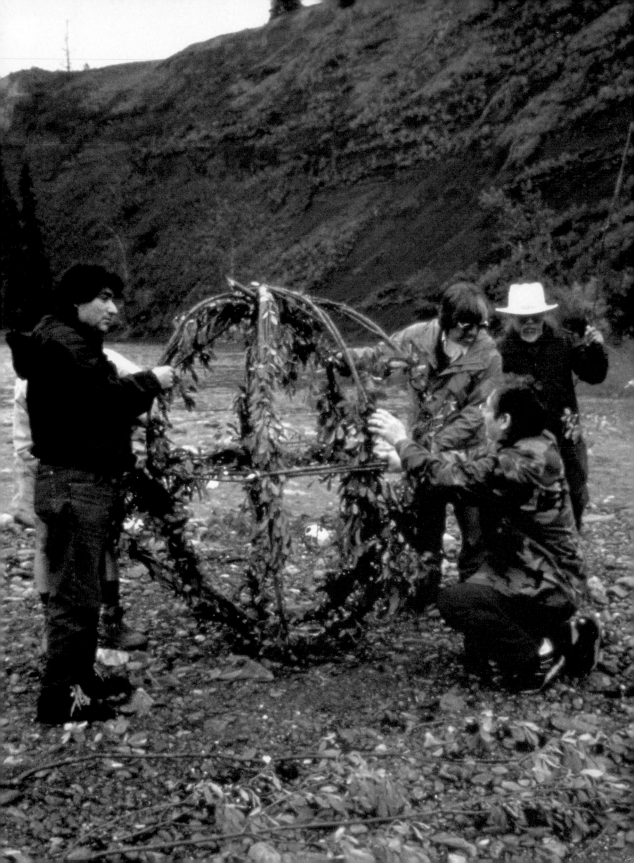

# Appendix

Dan Namingha,
Harold Littlebird,
Frank LaPena, and
LeVan Keola Sequeira
with sphere installation,
Banff, Alberta, Canada

*This Path We Travel* is an exhibition that will express the continuity of our culture. It will explore the idea that our tradition, while rich in a sense of the past, also responds to the participants of the present. The exhibition process will follow a path of exploration which looks both to the past and the future in understanding tradition as a series of cumulative steps that build on an understanding of the past and are modified by the creative influence and vision of the present day. Evolution of tradition as a dynamic process will also be modeled by the development of the exhibition.

Our collaboration is hemispheric in nature. We meet as artists from diverse cultures to create a unified composition of native thought, belief, and expression. The synthesis of our commonalities, as well as the diversity in the ways in which we interpret these ideas, will be presented.

The cycles of the cosmos, of the earth, of the seasons, and of human experiences are represented by the circle. The ongoing creation of life, of the earth, and of rebirth are used as a way to understand our universe. The earth and all of its glorification is our common intellectual and cultural element.

We emphasize the sacred four directions as well as the sacred center concept and reflect the relationship of the zenith and the nadir. This is emphasized through the format of our travels throughout the hemisphere. There will be a geographic, social, and cultural representation of the native cultures we have visited. Our work is influenced by our involvement and interaction with these native cultures.

We believe this installation is a form of ceremony and ritual. It is based upon an older native model of cooperation and sharing. The work will spring from the traditions of our people and will be radically new in form. We bring our own vision and experience to the ritual, which then becomes a multilayered vision of all the participants. Our collaboration therefore is an ancient continuous process.

## GUIDING PRINCIPLES OF THE COLLABORATION

1. Separate the visitors from their immediate environment as they enter the exhibition, in order to make a dramatic departure from their world to ours, and allow them to experience our understanding of the world.

2. The exhibition will be a total sensory experience, incorporating all of the arts as reflective of our cosmos.

3. The exhibition is about the creative process as projected by contemporary native artists, including both traditional techniques and new approaches.

4. The shape of the gallery space can be manipulated to reflect the concepts of the installation. The thinking should not be confined to the limitations of space. The environment and the content of the exhibition are to be wedded. The environment of the installation is to be an art form in itself.

5. The exhibition will be created by contemporary artists using contemporary means, reflecting our real environments, to show native art is more than just stylistic convention, but instead, reflects the dynamic and creative spirit of people who are still natives in the modern world.

6. There is a balance of the duties and perspectives of each gender within traditional native societies that will be represented in this installation.

7. As a living exhibition, performance will be interwoven periodically throughout the duration of this exhibition. There will also be an active participation of the artists in related educational programming associated with the exhibition.

8. There will be integrated use of multimedia within the very structure of the installation.

9. A photographic record will be used to explain the process by which the work was created.

10. The installation will do justice to our ancient past, present, and the future. The work will reflect the ancient tribal view of the cosmos. The task is to inform the public.

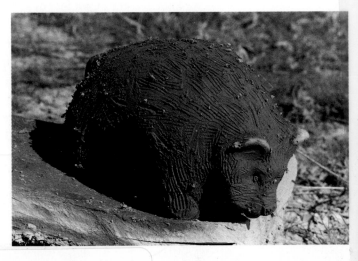

Art created on site,
Snaketown,
Gila River, Arizona